THE BEST OF

PASTEL

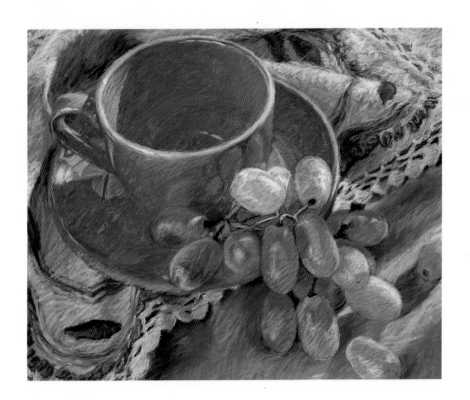

First published in the United States of America by:
Quarry Books, an imprint of
Rockport Publishers, Inc.
146 Granite Street
Rockport, Massachusetts 01966-1299
Telephone: (508) 546-9590
Fax: (508) 546-7141

Distributed to the book trade and art trade in the United States by:
North Light, an imprint of
F & W Publications
1507 Dana Avenue
Cincinnati, Ohio 45207
Telephone: (800) 289-0963

Other Distribution by:
Rockport Publishers
Rockport, Massachusetts 01966-1299

ISBN 1-56496-269-5

10 9 8 7 6 5 4 3 2 1

Art Director: **Lynne Havighurst**
Designer: **Sara Day Graphic Design**
Cover Images: Front cover, left to right: pp. 68, 16, 102
 background: p. 120
 Back cover, left to right: pp. 127, 46, 100

Printed by Welpac, Singapore.

THE BEST OF

PASTEL

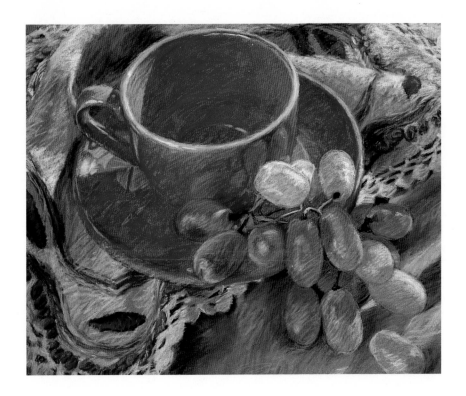

JURIED BY CONSTANCE FLAVELL PRATT AND JANET MONAFO

QUARRY BOOKS • ROCKPORT, MASSACHUSETTS

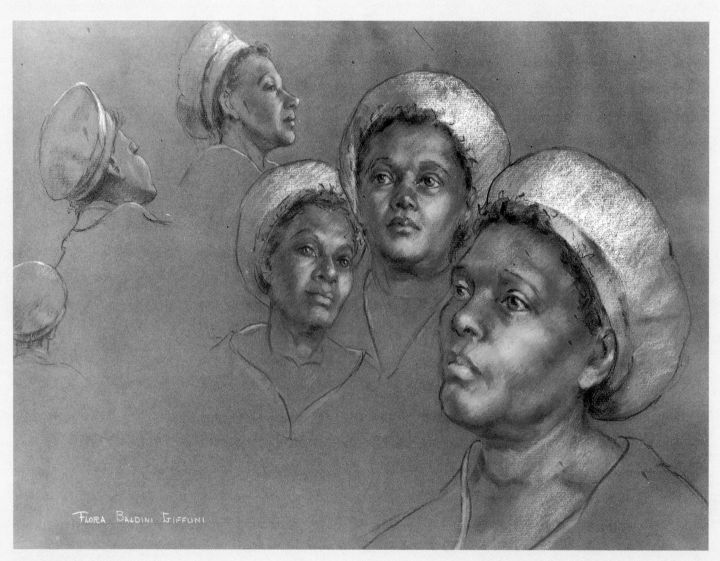

Flora B. Giffuni
Long Night's Journey into Day
18" x 24" (41 cm x 61 cm)
Canson paper

Introduction

Dear Pastel Enthusiasts,

Welcome to the Renaissance of Pastels.

Before I delve into the little-known history of our medium, let me describe what pastels are and what they are not!

Pastels have been misnamed chalks—limestone treated with colored dye—and crayons—those waxy colored sticks our children play with: Real pastels, however, are pure pigment; obtained from the stones in the earth and ground into powdered form. The difference between pastels, oil paints, watercolor paints, and gouache or tempera media, is the binder. Methyl cellulose is used, instead of the oil, gum arabic or egg binders used in the others. This liquid is mixed with the powder, to form a paste; thus, the word *pastel* is related to the French word *pastiche.* The paste is rolled into short sticks and allowed to dry. The pastels are then applied to any ground with a "tooth"—paper, cardboard, canvas, cloth, or on masonite.

Contrary to popular belief, pastel is the most durable of all media if kept from sunlight and humidity. It is also the oldest of all media. As far back as 15,000 B.C., murals were painted on the walls of the caves in Lascaux, France, and Altamira, Spain with pure colored stones extracted from the earth. These were the predecessors of pastel.

In the fifteenth century, da Vinci used dry pigment to color his drawings. However, Rosalba Carriera, a Venetian lady born in 1675, was the first to use pastel as a full-fledged medium.

In France, during the eighteenth century, Maurice Quentin de la Tour, Boucher, Chardin, Vigée Lebrun, Millet, Manet, and Morisot all used pastels. In the nineteenth century, French artists Renoir, Lautrec, Pissarro, Gauguin, and the "King of Pastels", Degas, continued their legacy.

In England in 1746, John Russell was called the "Prince of Pastels", while Mengs and Munch were the great practitioners of this medium in Germany. In Switzerland, Liotard used pastels exclusively. Picasso, Klee, Miró and de Kooning all used pastel in their works of art. In Italy, de Nittis inspired many, even Chase, in the use of pastel. In America, Mary Cassatt, Whistler, W. Merritt Chase, Childe Hassam, Robert Henri, and Everett Shinn bring us to the present.

Today, there are more than one hundred Master Pastellists; many of whom (including Daniel Greene and yours truly) were taught by the great pastel artists Robert Brackman and Robert Philipp.

Albert Handell, Ramon Kelley and Constance F. Pratt, among other living artists, are all superb exponents of our glorious medium.

Proudly,

Flora B. Giffuni
Founder, President Emeritus, and
Chairperson of the 23-year-old
Pastel Society of America

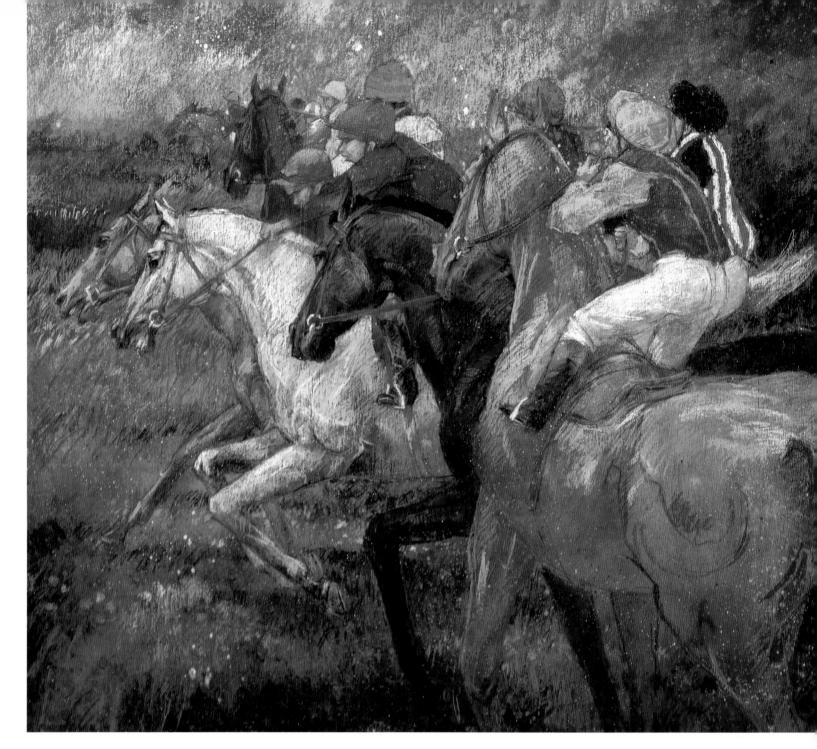

Fay Moore
Derby Action
30" x 48" (76.2 cm x 121.9 cm)
Mahogany-laminated panel

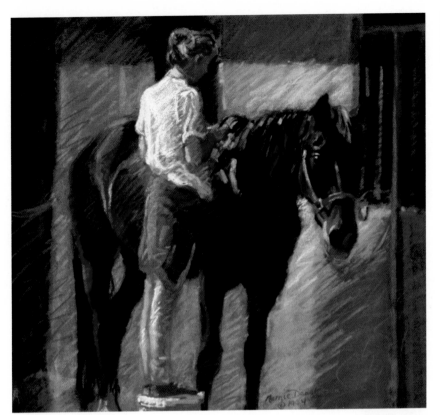

Marnie Donaldson
Braiding II
15.5" x 15.5" (39.4 cm x 39.4 cm)
La Carte pastel paper

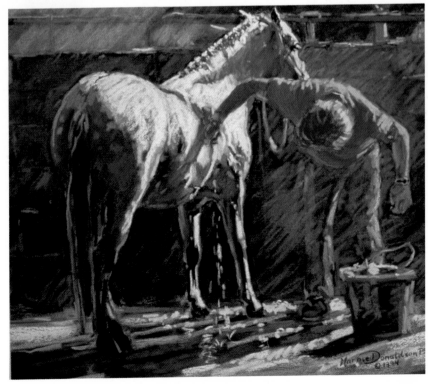

Marnie Donaldson
Pony Hide & Elbow Grease
15.5" x 17.5" (39.4 cm x 44.5 cm)
La Carte pastel paper

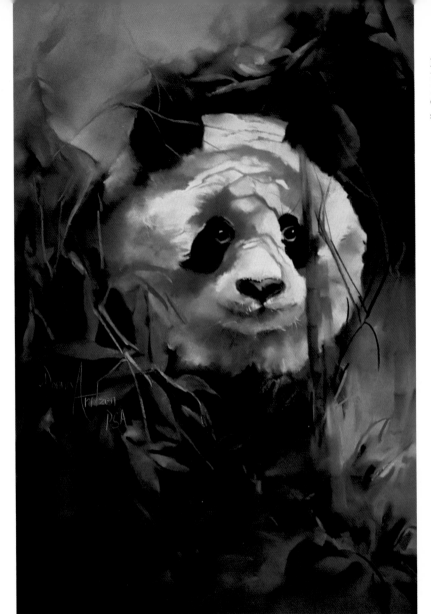

Donna L. Arntzen
The Endangered Panda
16" x 13" (40.6 cm x 33 cm)
German Ersta fine-buff 7/0 grit
sanded paper

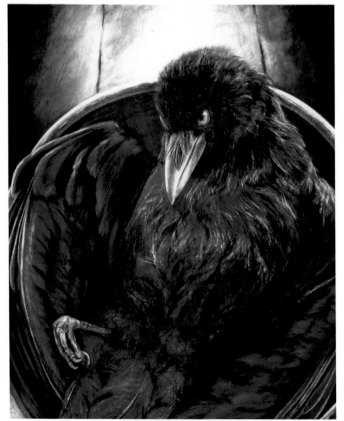

Andrea Burchette
Beauty Becomes a Bowl
65" x 56" (162.1 cm x 142.2 cm)
Pastel with charcoal
Somerset textured 250 lb. paper,
mounted on linen

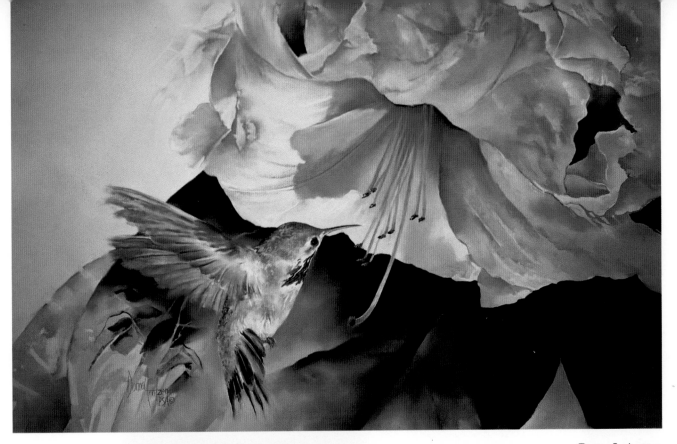

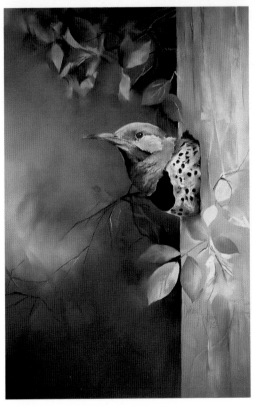

Donna L. Arntzen
Garden Gem - Calliope
15" x 20" (38.1 cm x 50.8 cm)
German Ersta fine-buff 7/0 grit sanded
pastel paper

Donna L. Arntzen
Watchful Eye - Northern Flicker
20" x 15" (50.8 cm x 38.1 cm)
German Ersta fine buff 7/0 grit sanded
pastel paper

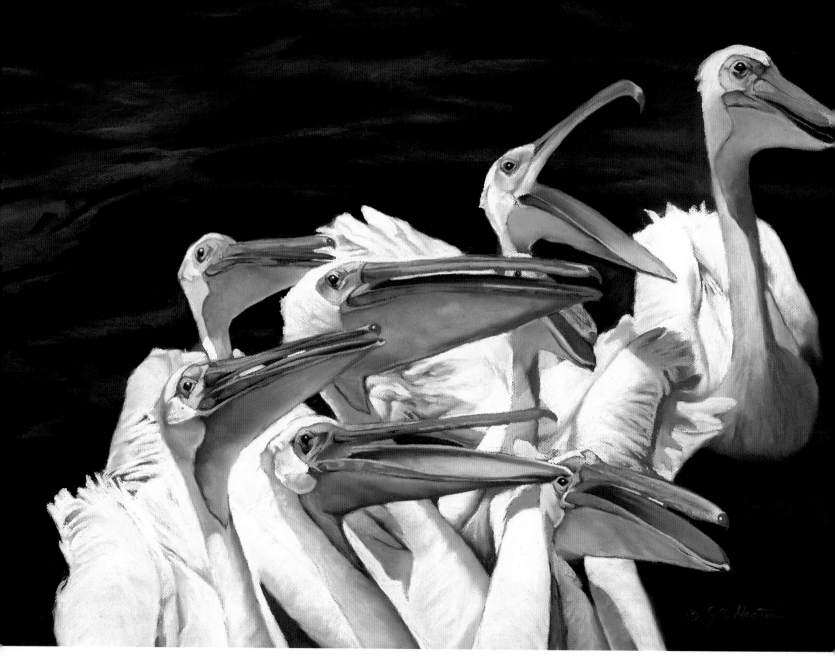

Janet N. Heaton
Zaire's White Pelicans
32" x 40" (81.3 cm x 101.6 cm)
Canson pastel paper

Valerie Trozelle
Lunchbell
22" x 24" (55.9 cm x 61 cm)
Pastel with watercolor
Velour paper

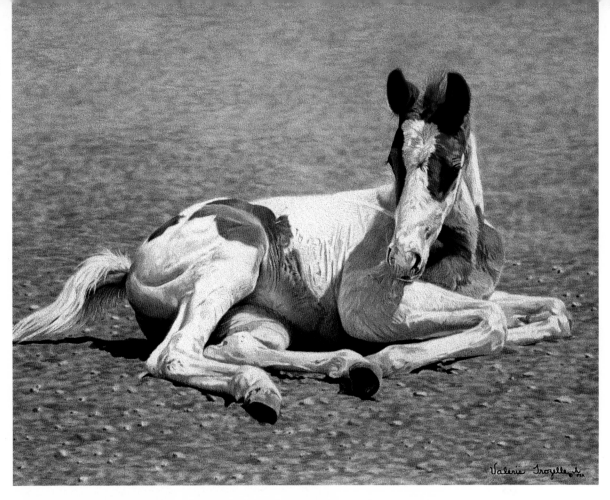

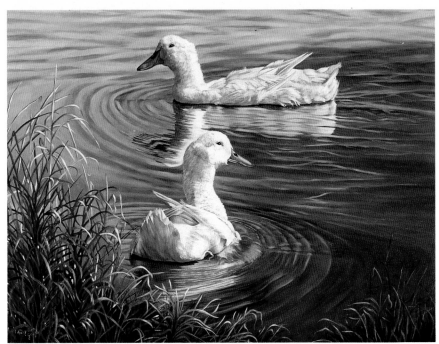

Peggy Ann Solinsky
Sunday Afternoon
22" x 28" (55.9 cm x 71.1 cm)
Masonite board

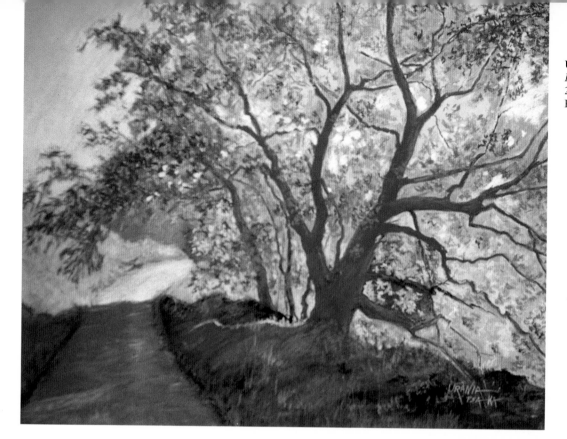

Urania Christy Tarbet
Ranch Road-Sunrise
24" x 30" (61 cm x 76.2 cm)
Fredrix sanded canvas

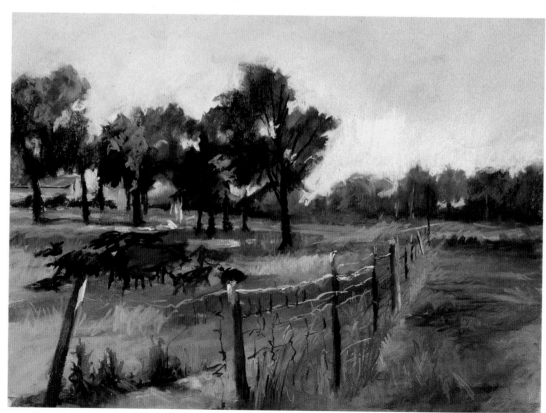

Denise E. Matuk-Kroupa
Buck's Schoolhouse Farm
24.5" x 31" (62.2 cm x 78.7cm)
Sanded paper

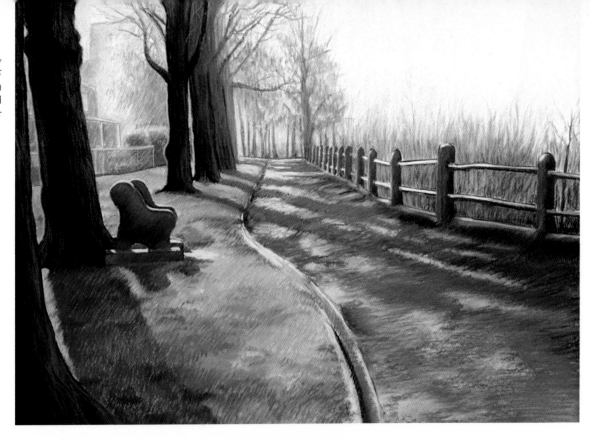

Kathy Shumway-Tunney
Morning-Hill Top Park © 1995
19" x 25" (48.3 cm x 63.5 cm)
German fine-grit sanded
pastel paper

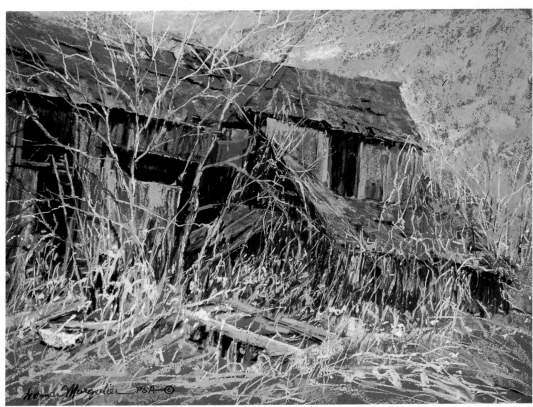

Herman Margulies
Abandoned #56
16" x 22" (40.6 cm x 55.9 cm)
Pastel with acrylic
Pumice-, acrylic- and pigment-coated
acid-free 4-ply museum rag board

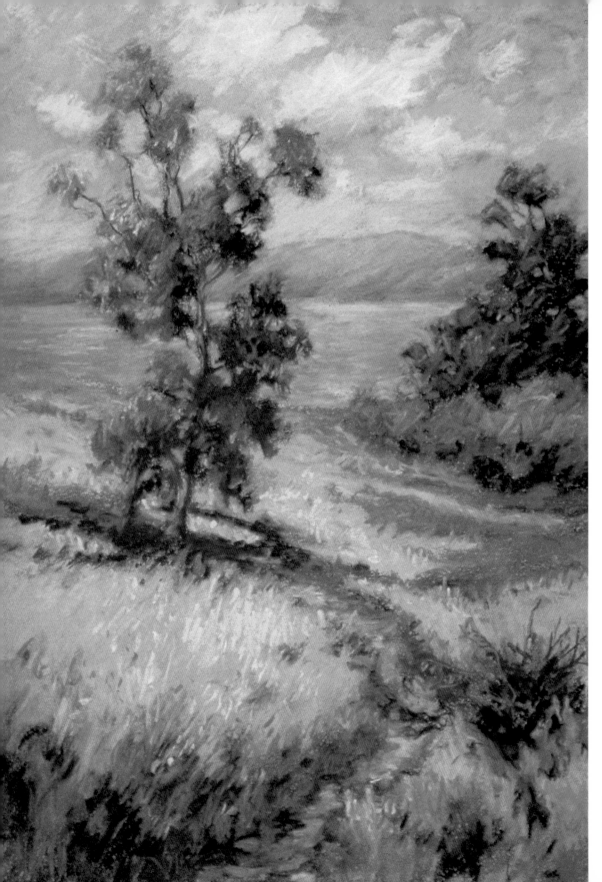

Kay Bonanno
Standing Tall
21.5" x 15" (54.6 cm x 38.1 cm)
Sanded paper

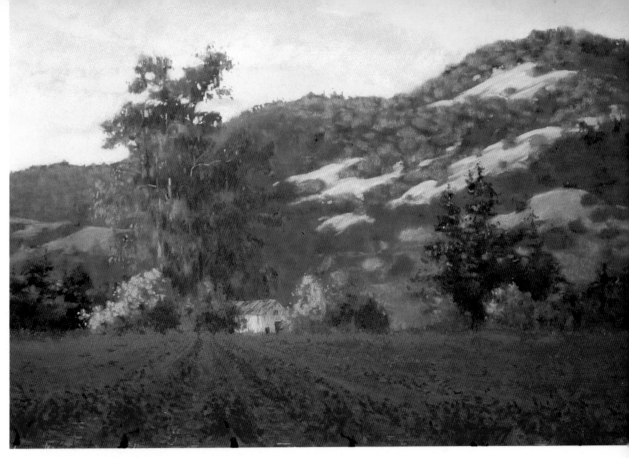

Clark G. Mitchell
Autumn Grapevines
15" x 21.5" (38.1 cm x 54.6 cm)
Pastel with turpentine
La Carte pastel paper

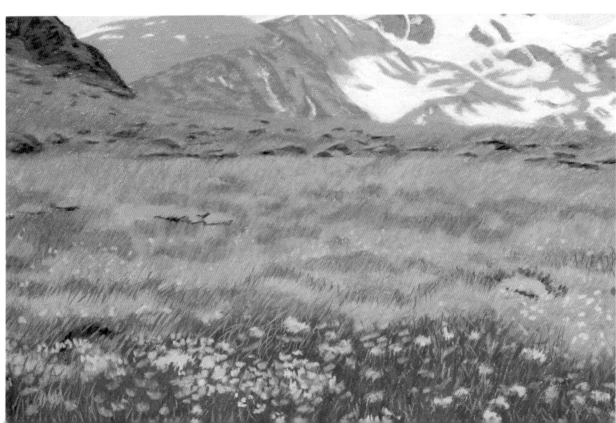

Diana Randolph
Rocky Mountain Wildflowers
18" x 24" (45.7 cm x 61 cm)
La Carte 200 lb. pastel card

17

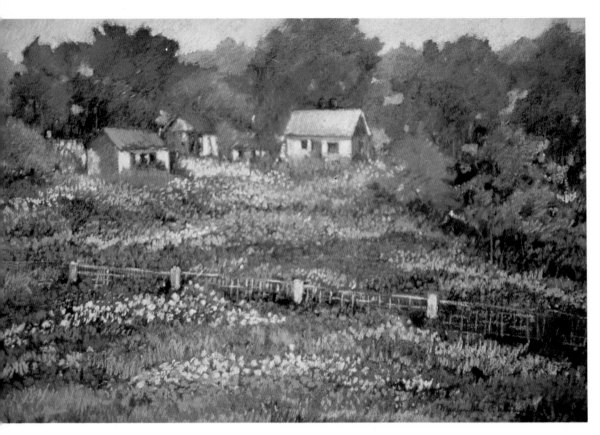

Madlyn-Ann C. Woolwich
Flower Hill
22" x 28" (55.9 cm x 71.1 cm)
Pastel with acrylic
Gesso- and pumice-treated
8-ply museum board

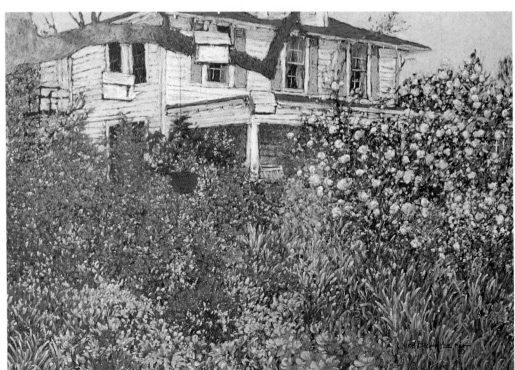

Alice Bach Hyde
Southern Spring
21.5" x 26.5" (54.6 cm x 67.3 cm)
Ersta Starcke 7/0 grit pastel
sandpaper

Anatoly Dverin
My Backyard
12" x 16" (30.5 cm x 40.6 cm)
Canson Ingres pastel paper, tint #55

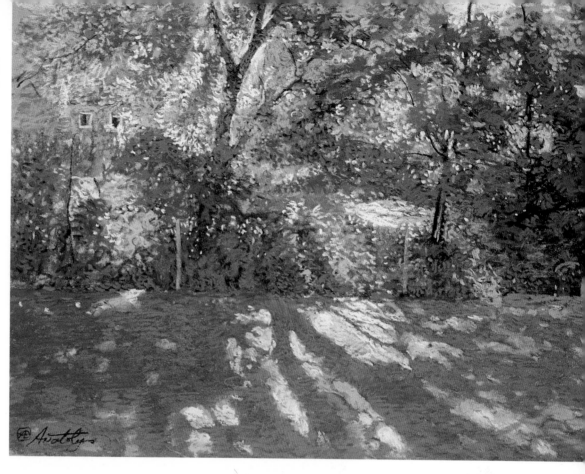

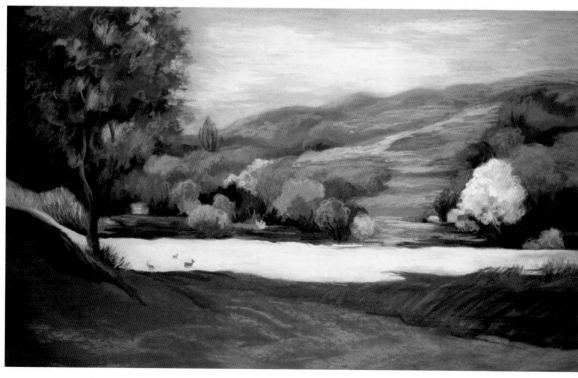

Dorothy Davis Thompson
Late Afternoon Luster
14" x 20" (35.6 cm x 50.8 cm)
Ersta 7/0 grit sanded paper

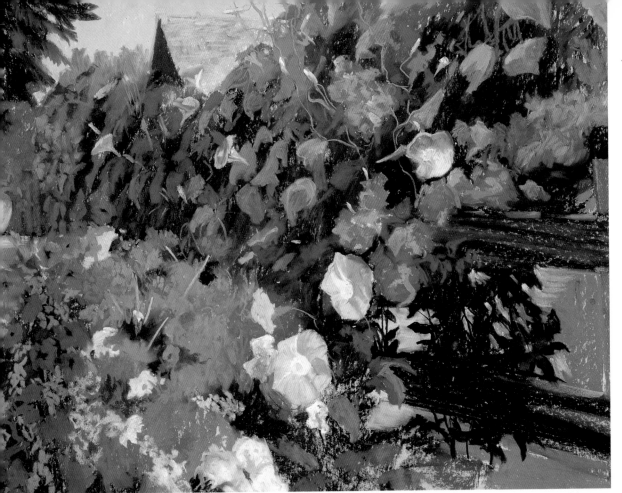

Judith Scott
Magnificent Morning Glories
22" x 28" (55.9 cm x 71.1 cm)
Handmade pastel surface on
100% rag illustration board

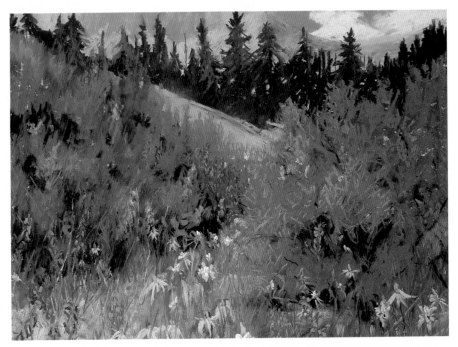

Judith Scott
Rocky Mountain Garden
22" x 28" (55.9 cm x 71.1 cm)
Ersta 7/0 sandpaper

Coralie Alan Tweed
Bank of Poppies
30" x 22" (76.2 cm x 55.9 cm)
Pastel with gouache
underpainting
Arches 130 lb. hot press
watercolor paper

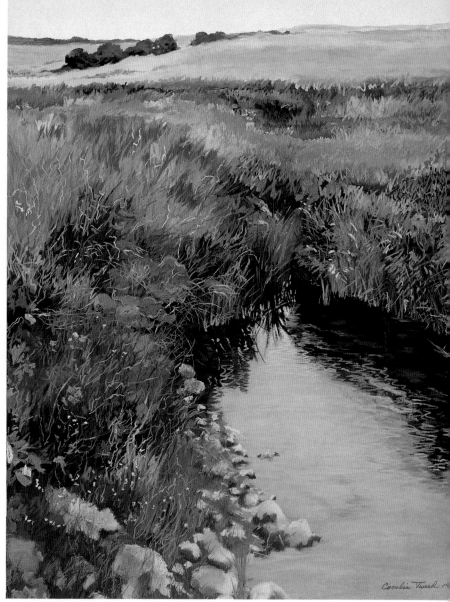

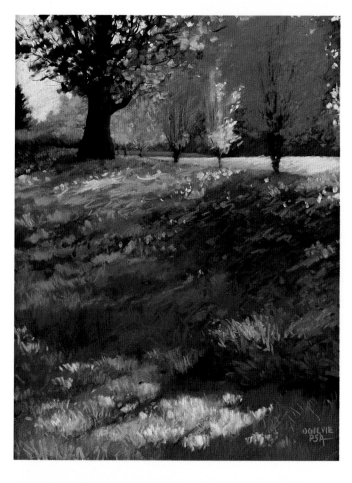

Susan Ogilvie
Autumn Road
17" x 13" (43.2 cm x 33 cm)
La Carte pastel board

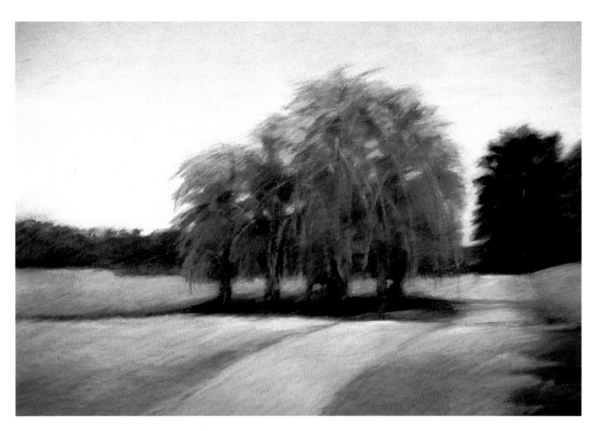

Eugenie Torgerson
Sentry Willows
16" x 23" (40.6 cm x 58.4 cm)
La Carte pastel card

Eugenie Torgerson
Tell Me About Blue Heron Creek
8" x 12" (20.3 cm x 30.5 cm)
La Carte pastel card

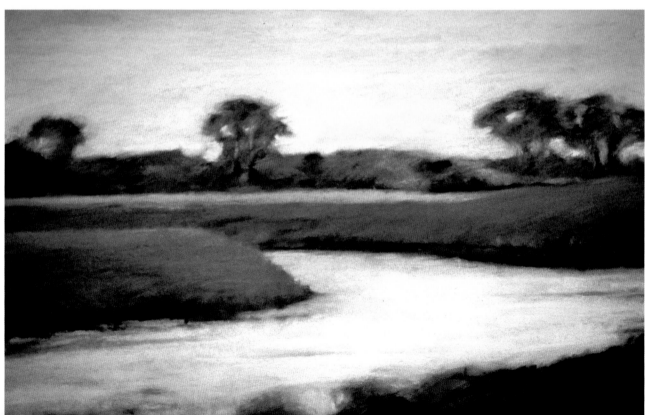

Donna Levinstone
Season Suite IV
15" x 19" (38.1 cm x 48.3 cm)
Stonehenge paper

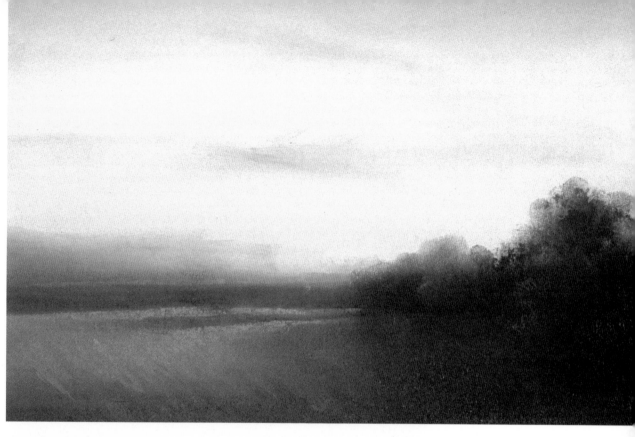

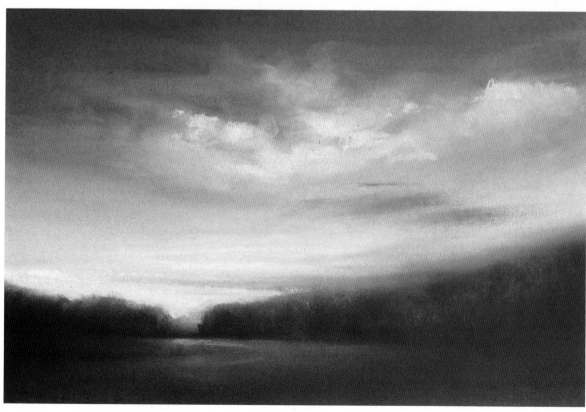

Donna Levinstone
Season Suite I
15" x 19" (38.1 cm x 48.3 cm)
Stonehenge paper

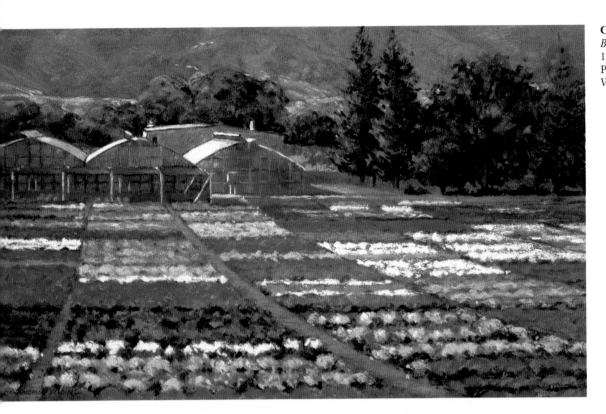

Claire Schroeven Verbiest
Bumper Crop
13" x 22" (33 cm x 55.9 cm)
Pastel with watercolor
Wallis 140 lb. sanded pastel paper

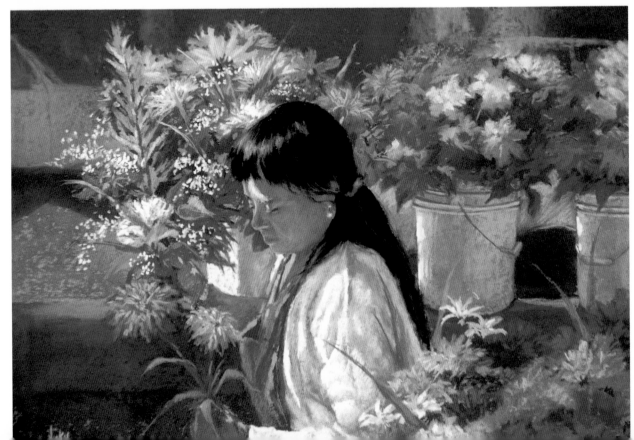

Vicky Clark
Seattle Flower Market
17" x 23" (43.2 cm x 58.4 cm)
Ebony Minwax-furniture-
stained, 7/0 grit sanded paper

Agnes Harrison
Autumn Glow
21" x 27" (53.3 cm x 68.6 cm)
Pastel with oil and turpentine
Ersta Starcke 7/0 sanded pastel paper

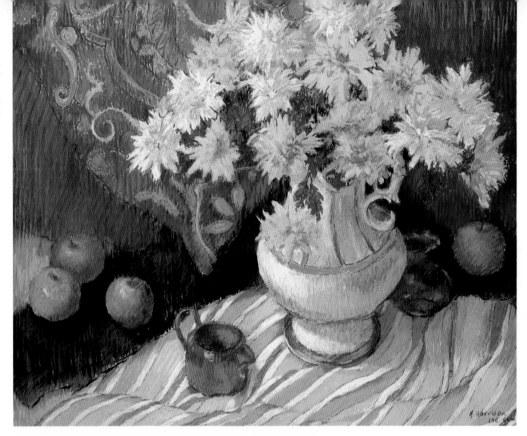

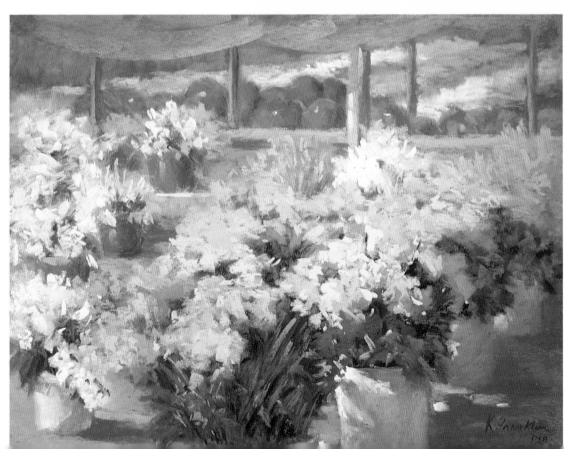

Kaye Franklin
Fall Market
11" x 14" (27.9 cm x 35.6 cm)
Ersta 5/0 grit sanded paper

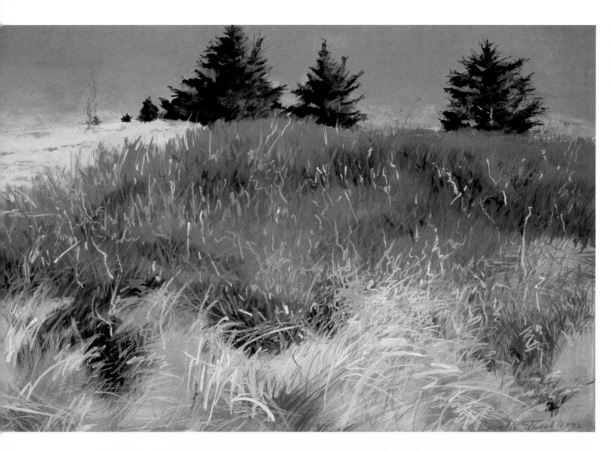

Coralie Alan Tweed
Roan Mt. Blackberry Bushes
25" x 32" (63.5 cm x 81.3 cm)
Pastel with gouache and gesso
Arches 130 lb. hot press paper

Elizabeth M. Mowry
Roadside, October
24" x 41" (61 cm x 104.1 cm)
Ersta Starcke sanded paper

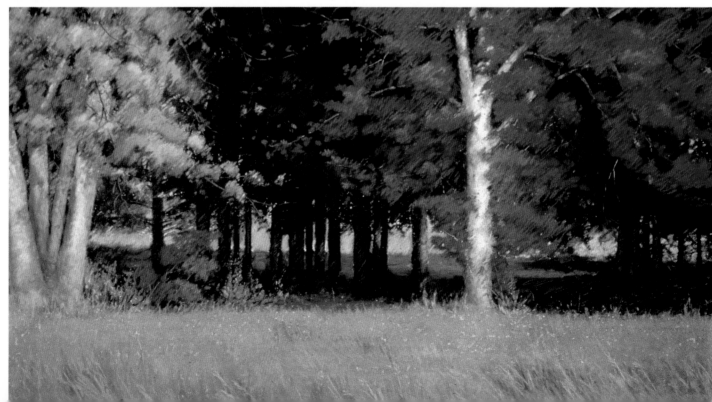

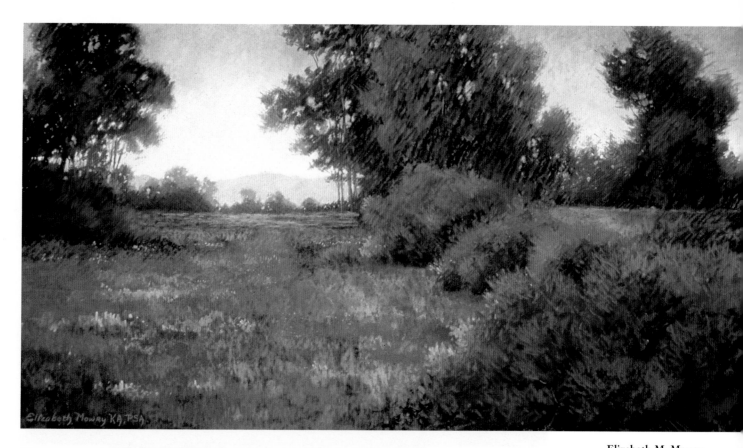

Elizabeth M. Mowry
September
20" x 38" (50.8 cm x 96.5 cm)
Sanded board

Coralie Alan Tweed
The Sentinels
40" x 51" (101.6 cm x 129.5 cm)
Pastel with gouache and gesso
Gesso-coated Strathmore
400 paper

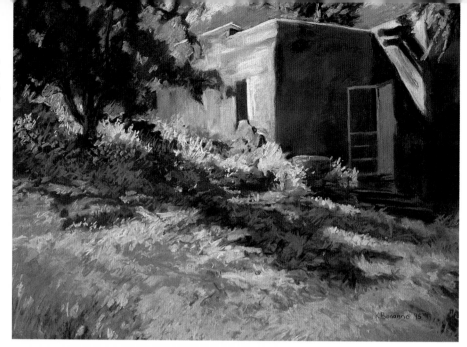

Kay Bonanno
Interlude
18" x 24" (45.7 cm x 61 cm)
Sanded paper

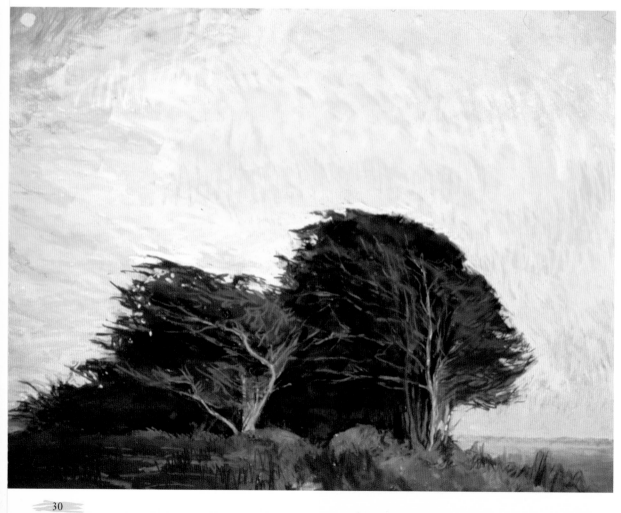

Kitty Wallis
Cypress
22" x 28" (55.9 cm x 71.1 cm)
Pastel with acrylic-wash underpainting
Sandpaper

Albert Handell
November Snow
16" x 16" (40.6 cm x 40.6 cm)
Sanded pastel board

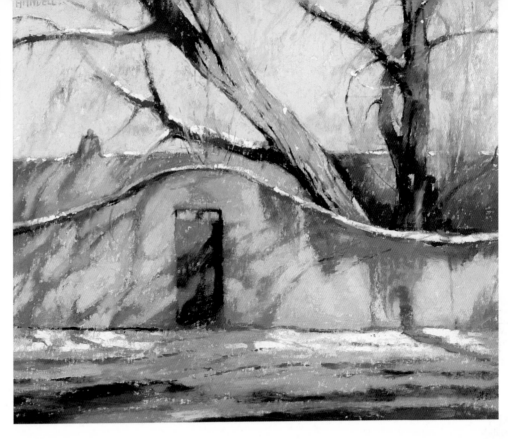

Jann T. Bass
Pueblo Adobe
7" x 12" (17.8 cm x 30.5 cm)
140 lb. Hot press 100% rag water-
color paper

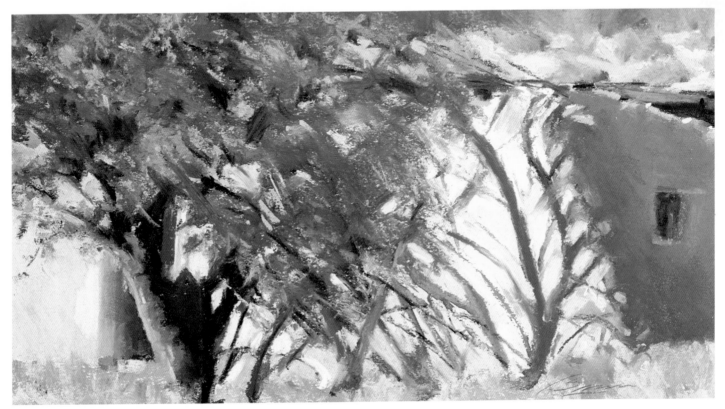

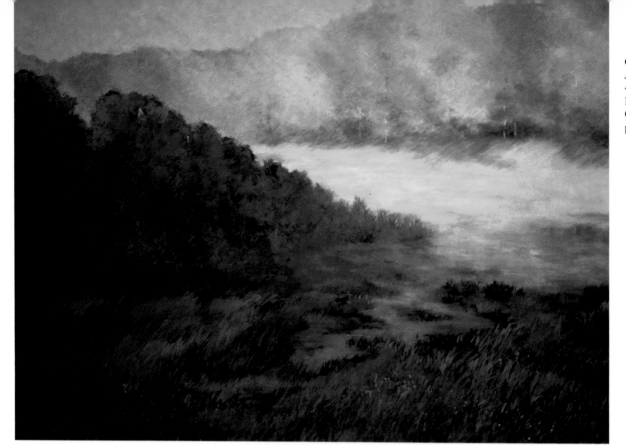

Coralie Alan Tweed
Autumn Brilliance
48" x 60" (121.9 cm x 152.4 cm)
Pastel with gouache and gesso
Gesso-coated Strathmore 400
paper

Gregory Stephen McIntosh
Atmospheric Expression
4" x 5" (10.2 cm x 12.7 cm)
Pastel with gouache
Stonehenge 320 lb. paper

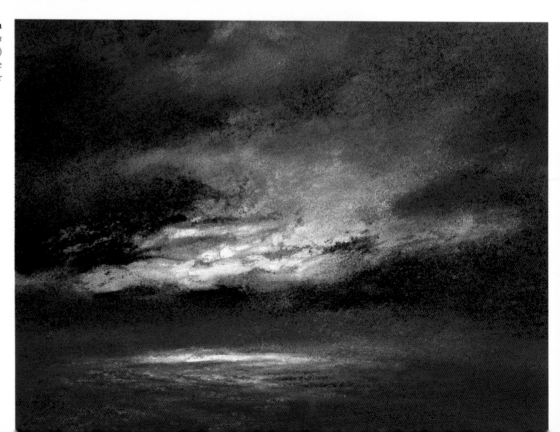

Lorrie B. Turner
Land's End
18" x 24" (45.7 cm x 61 cm)
Canson Mi-Teintes paper

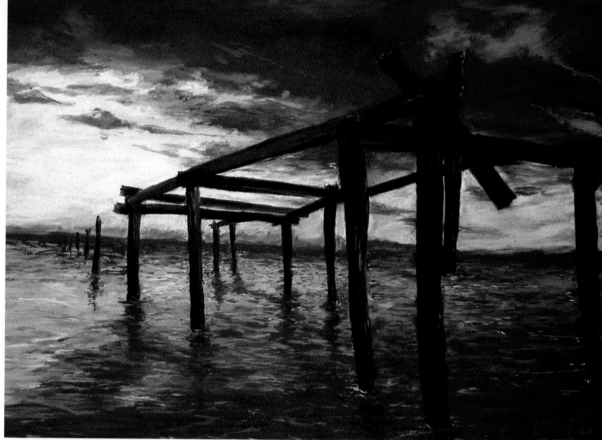

Carole Chisholm Garvey
Shadows on the Beach
10" x 15" (25.4 cm x 38.1 cm)
Canson paper

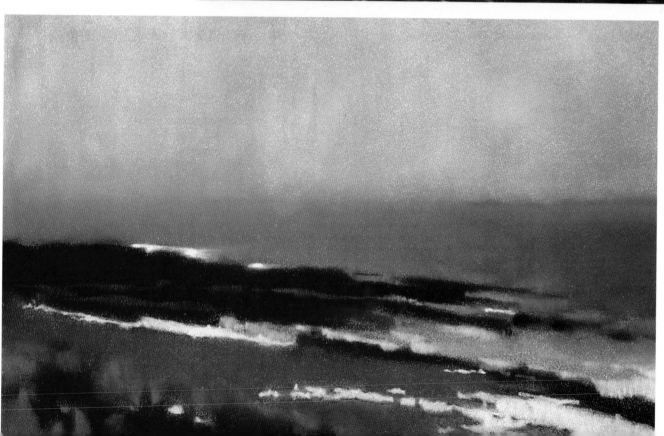

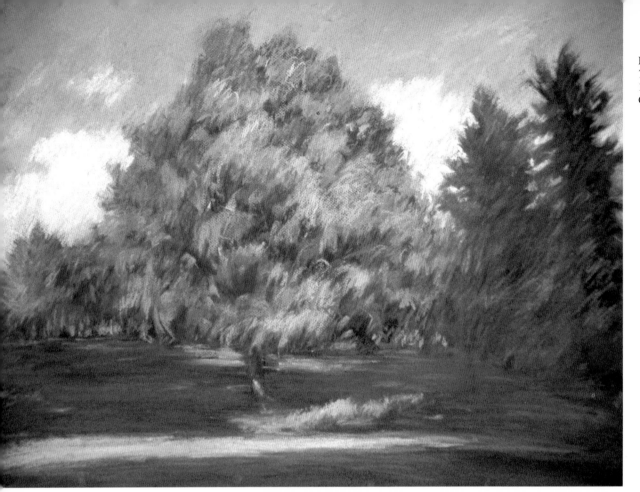

Beatrice Goldfine
Tree of Hope
19.5" x 25" (49.5 cm x 63.5 cm)
Canson pastel paper

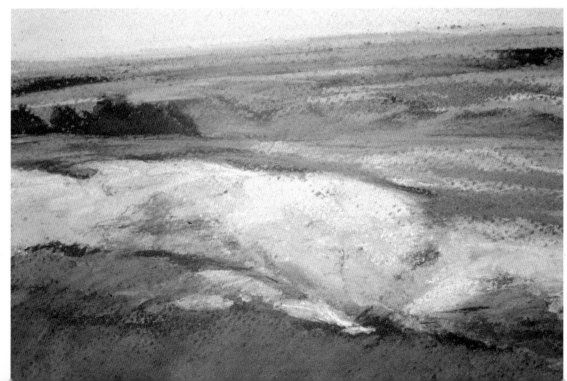

Kathy A. Legere
The Badlands
5.5" x 8" (13.9 cm x 20.3 cm)
175 lb. 65% rag pastel paper

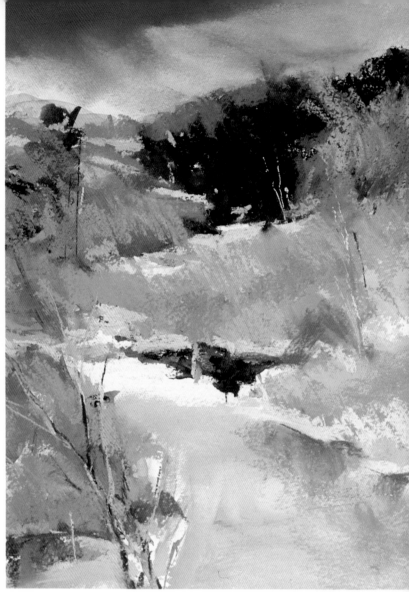

Carole Chisholm Garvey
Sampson's Island, Fall
11.5" x 10" (29.2 cm x 25.4 cm)
Canson paper

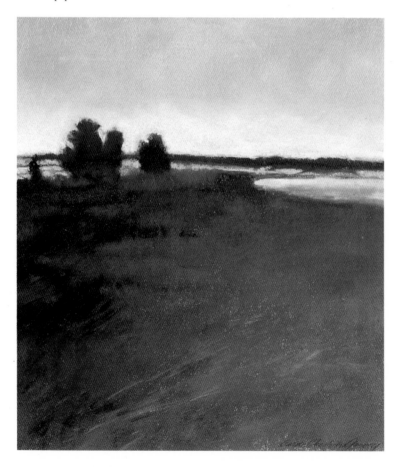

<div align="right">

Jann T. Bass
Spring Burnish II
12" x 9" (30.5 cm x 22.9 cm)
Pastel with watercolor
140 lb. Hot press 100% rag
watercolor paper

</div>

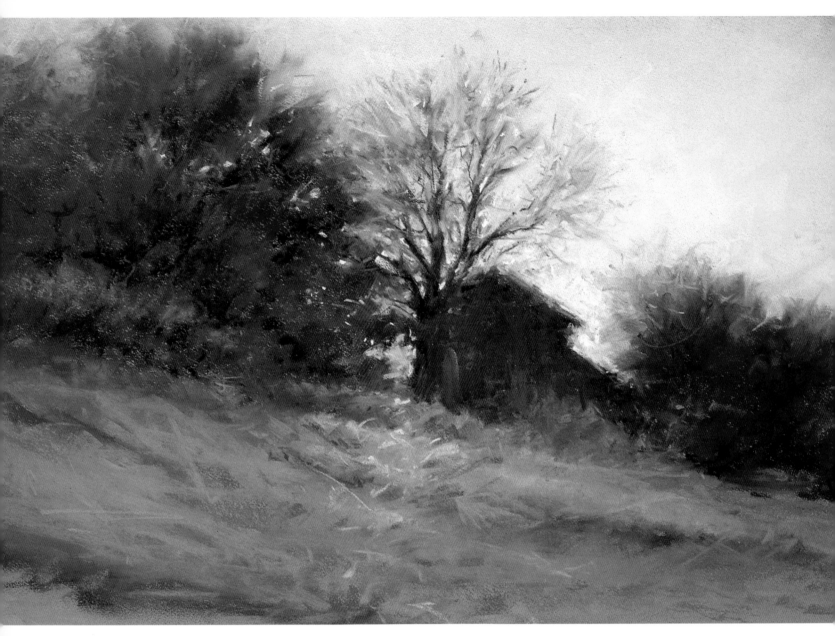

David Garrison
Country Shadows
14" x 24" (35.6 cm x 61 cm)
Verge gallery-surface Canson paper

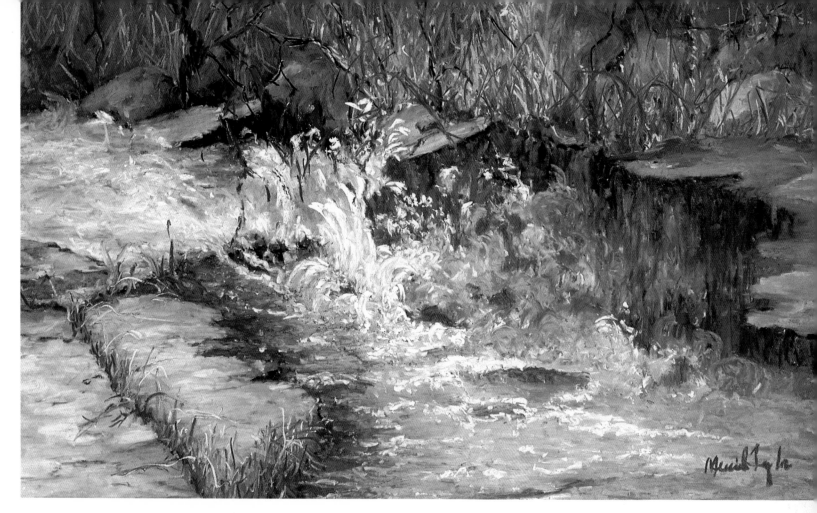

Merriel Taylor
The Water Dance
11" x 18" (27.9 cm x 45.7 cm)
Ersta 7/0 sandpaper

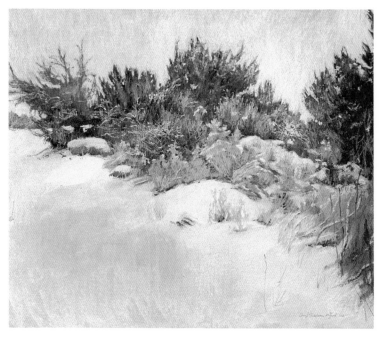

Cheryl O'Halloran-McLeod
Las Primeras Nieves del Ontono
21" x 24" (53.3 cm x 61 cm)
Sanded board

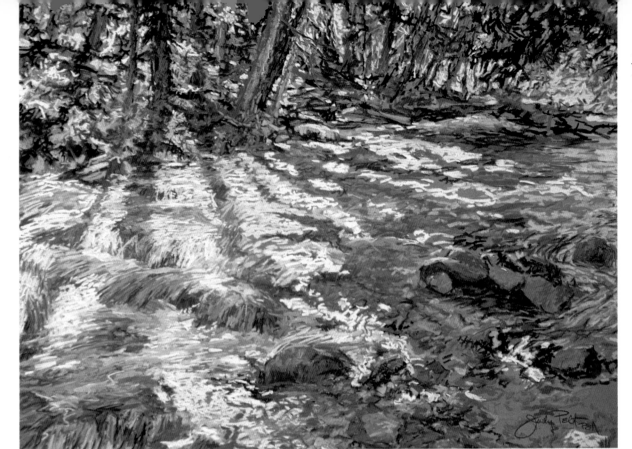

Judy Pelt
And There Was Light
22" x 28" (55.9 cm x 71.1 cm)
Production paper

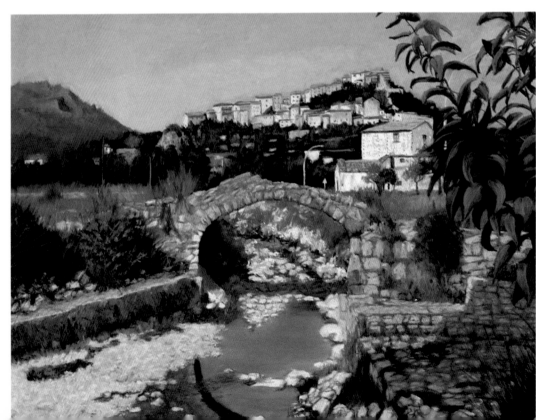

Phyllis J. Friel
Ausonia
24" x 30" (61 cm x 76.2 cm)
007 Sanded paper

Christine Debrosky
Winter Wood
19" x 25" (48.3 cm x 63.5 cm)
Sanded pastel paper

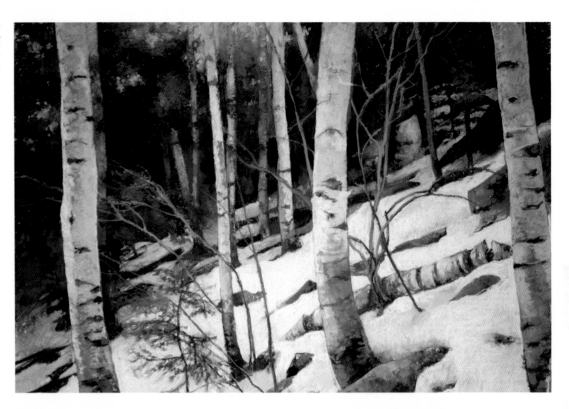

Frank E. Zuccarelli
Pottersville
18" x 24" (45.7 cm x 61 cm)
Gesso- and pumice-treated
watercolor board

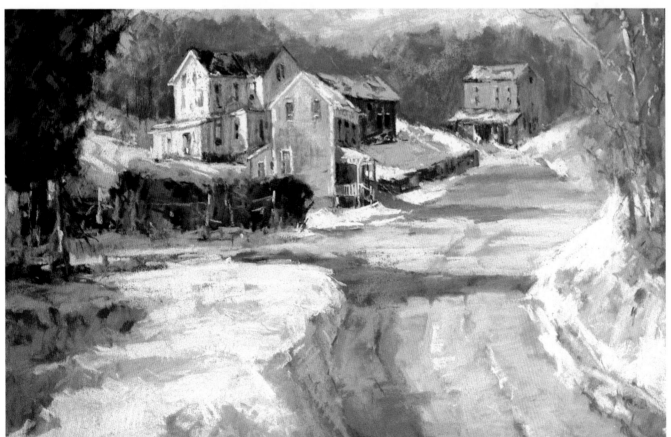

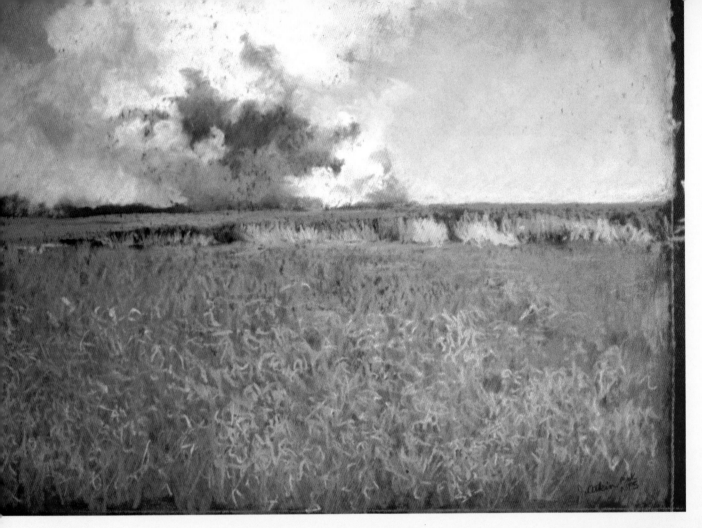

Jill Atkin
Field Burning III
36" x 42" (91.4 cm x 106.7 cm)
Ersta paper

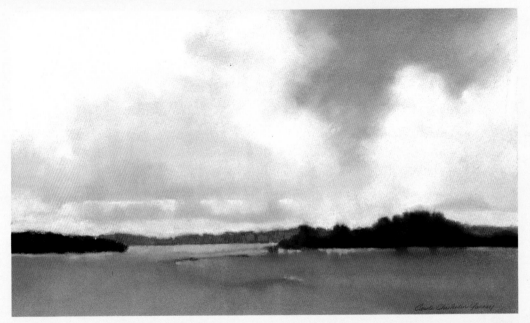

Carole Chisholm Garvey
Indian Summer
13.5" x 24" (34.3 cm x 60.3 cm)
Canson paper

Anne Heywood
To the Ocean
25" x 18" (63.5 cm x 45.7 cm)
Granular board

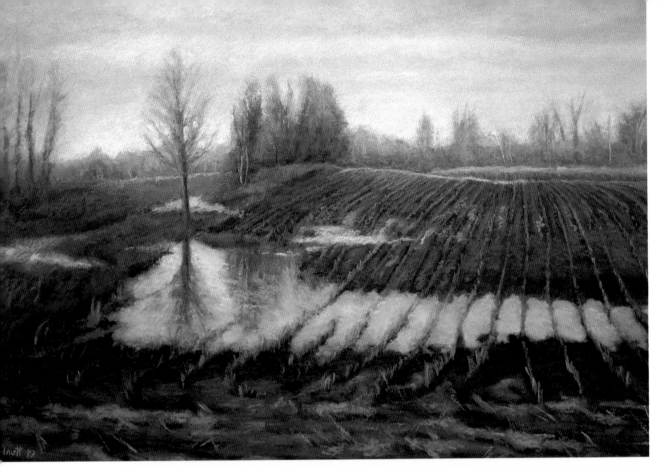

Pamela G. Allnutt
Early Thaw
22" x 32" (55.9 cm x 81.3 cm)
Pastel with gouache under-
painting
Gesso- and mable dust-
prepared 100% rag cold
press illustration board

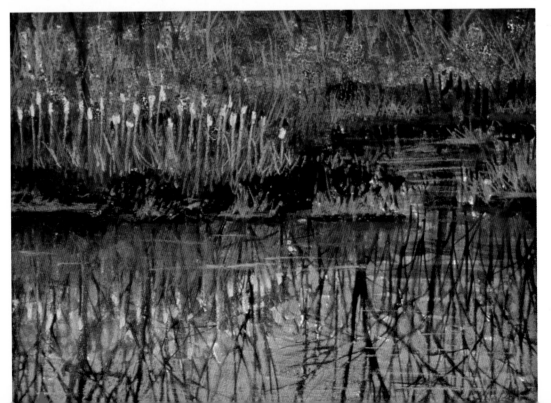

Linda Meiegs
Earth & Sky III
10.5" x 13.5"
(26.7 cm x 34.3 cm)
Pastel with watercolor
Rives BFK paper

Pamela G. Allnutt
The Coming of Winter
30" x 40" (76.2 cm x 101.6 cm)
Pastel with goauche underpainting
Gesso- and marble dust-treated 100%
rag cold press illustration board

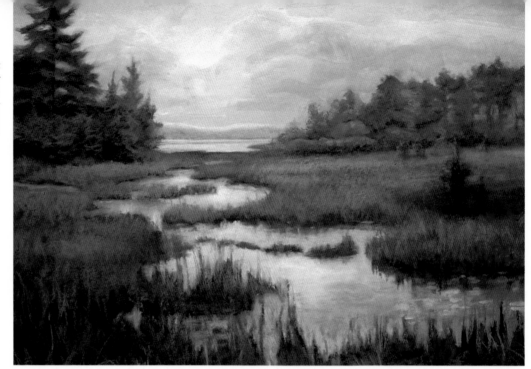

Donna Neithamner
Dusty Legs
16" x 23" (40.6 cm x 58.4 cm)
Canson Mi-Teintes paper

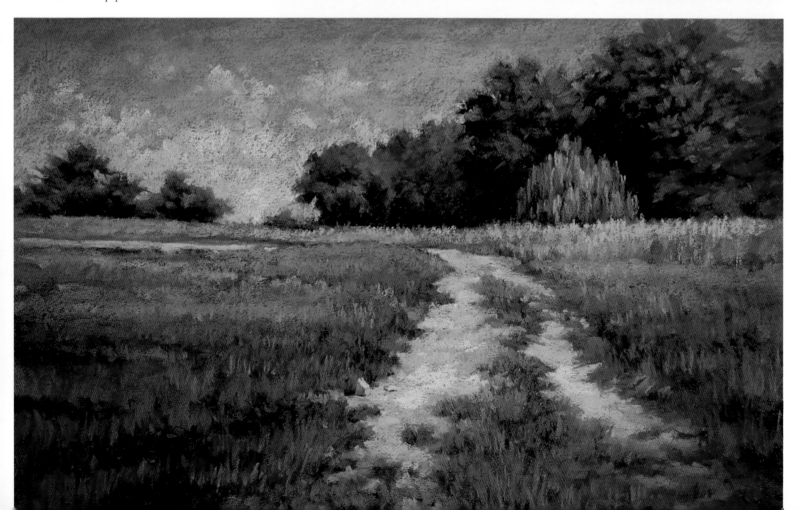

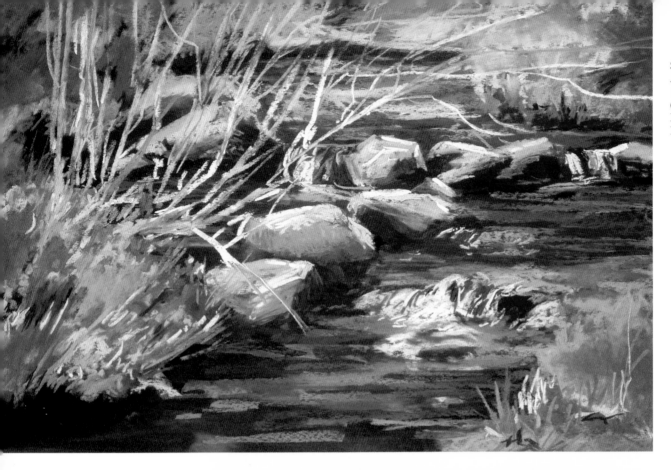

Sue Bennett
Looking Upstream
12.5" x 19.5"
(31.8 cm x 49.5 cm)
Pastel with watercolor
Ersta 1/0 sanded paper

Deborah Nieto Leber
Central Park
27.5" x 43"
(62.2 cm x 94.1 cm)
Pastel

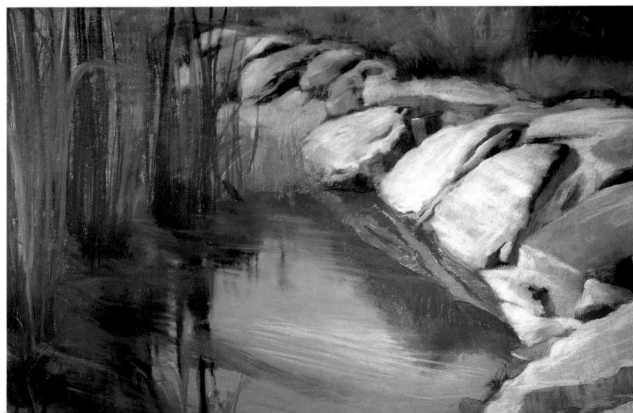

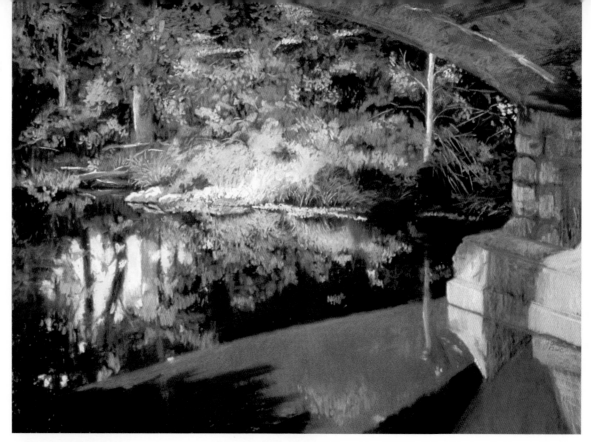

Jill Atkin
Vantage Point II
36" x 42" (91.4 cm x 106.7 cm)
Ersta paper

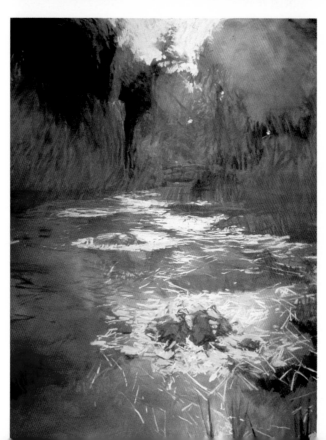

Kitty Wallis
Morning Mist #1
54" x 40" (137.2 cm x 101.6 cm)
Pastel with acrylic
Sandpaper

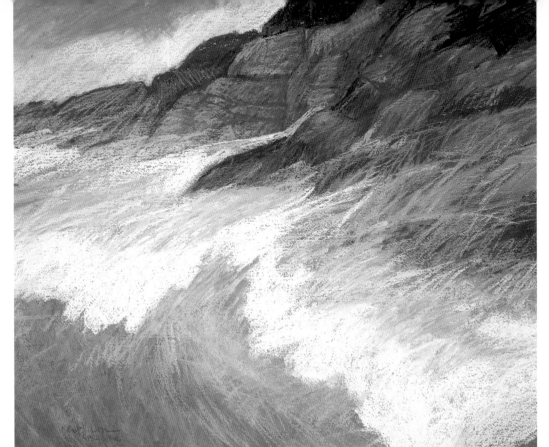

Marsh Nelson
Sea Rises
17.5" x 19.5" (44.5 cm x 49.5 cm)
Pastel with acrylic and extra fine pumice
Arches 140 lb. cold press paper

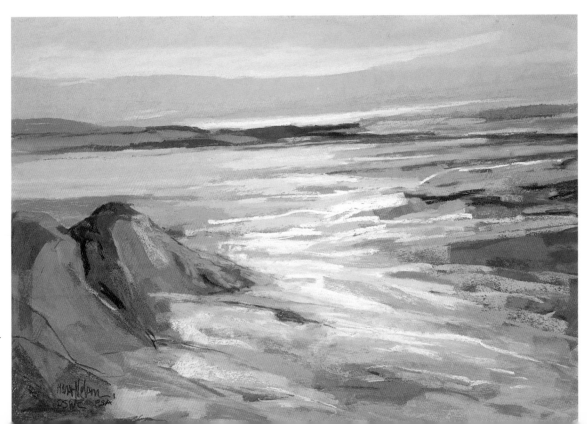

Marsh Nelson
Blue Surf
15" x 20" (38.1 cm x 50.8 cm)
Rising Stonehenge 100%
cotton acid-free paper

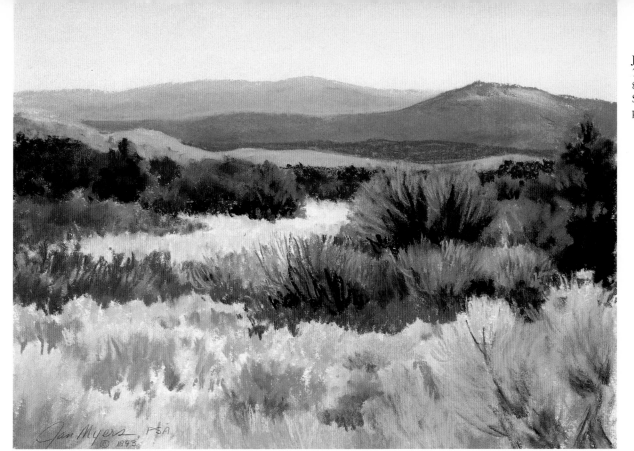

Jan Myers
Turquoise Trail in Autumn
8" x 11" (20.3 cm x 27.9 cm)
Stonehenge 180 lb. printmaking
paper

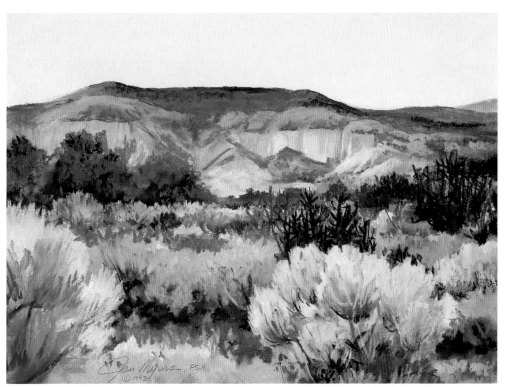

Jan Myers
Evening Sagebrush
11" x 15" (27.9 cm x 38.1 cm)
Stonehenge 180 lb. printmaking
paper

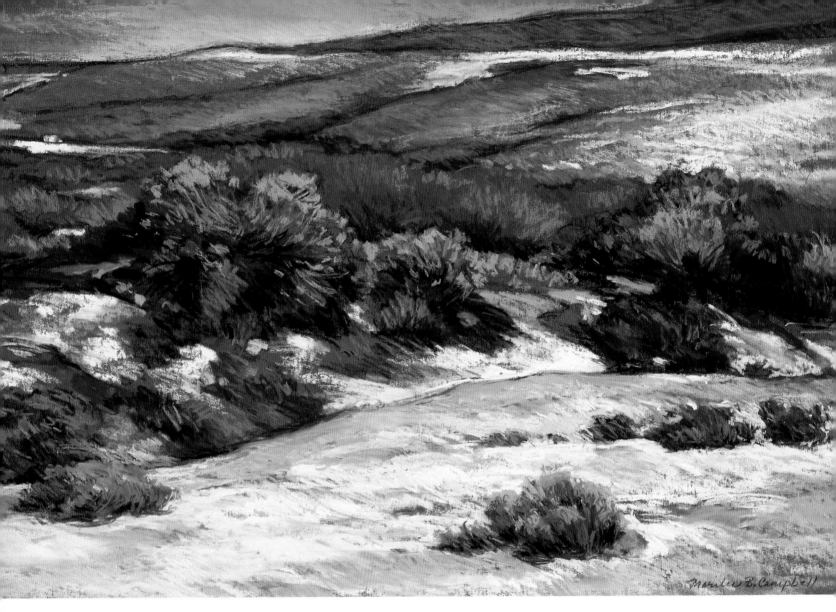

Marilee B. Campbell
Winter Warmth
13" x 20" (32.4 cm x 50.8 cm)
Toned sanded paper

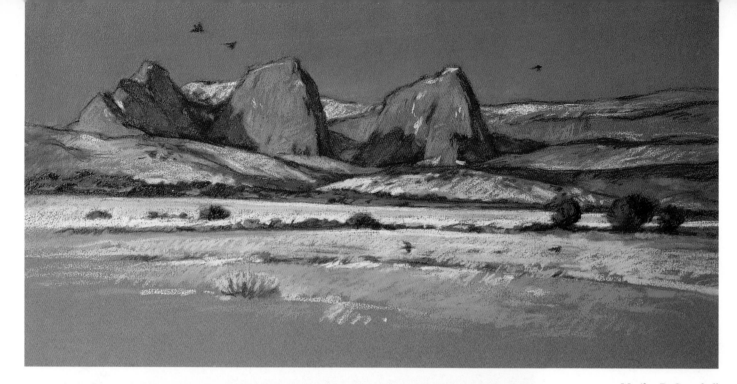

Marilee B. Campbell
Winter Afternoon - Kolob
10" x 18" (24.8 cm x 45.7 cm)
Canson blue paper

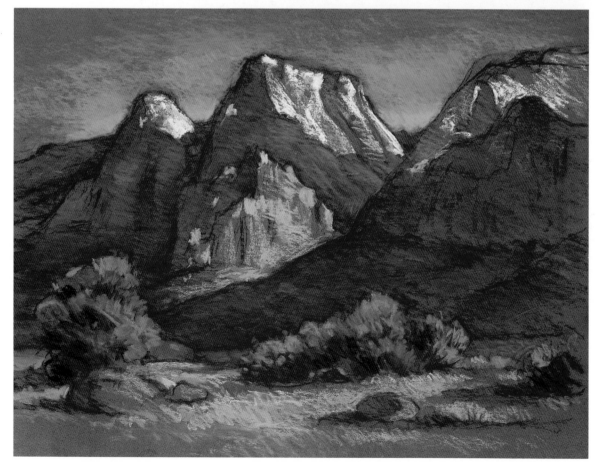

Marilee B. Campbell
Zion Sunrise in Deep Tones
11" x 14" (27.9 cm x 35.6 cm)
Toned sanded paper

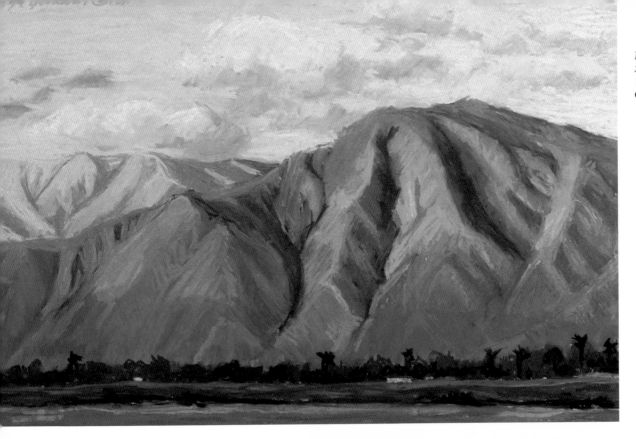

Maggie Goodwin
Sundown on the Desert
10" x 16" (25.4 cm x 40.6 cm)
German finely sanded paper

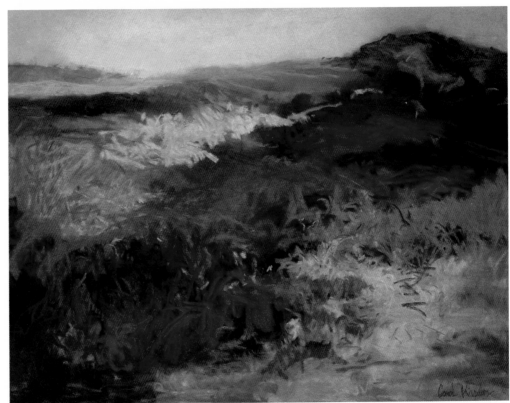

Carol Kardon
Faraway
19.5" x 25.5" (49.5 cm x 64.8 cm)
Sennelier French pastel card

Barry G. Pitts
Autumn Contrast
23" x 27.5" (58.4 cm x 69.9 cm)
Pastel with turpentine
Sanded board

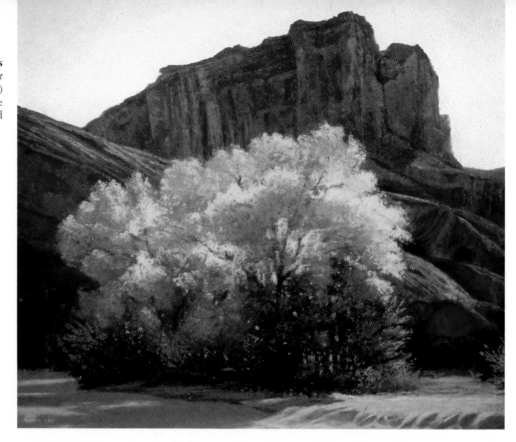

Phyllis J. Friel
Window Rock
19" x 25" (48.3 cm x 63.5 cm)
007 Sanded paper

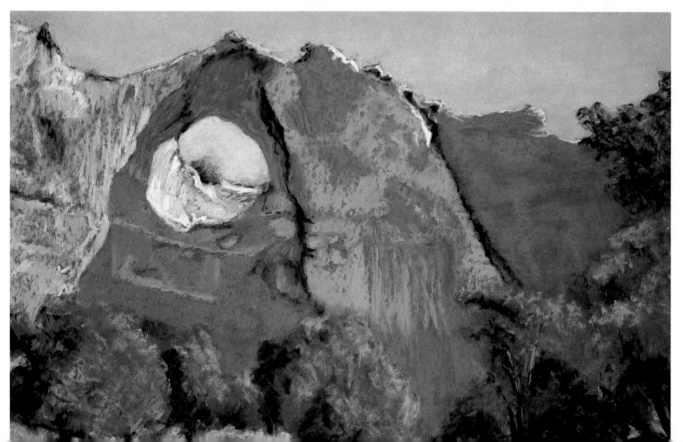

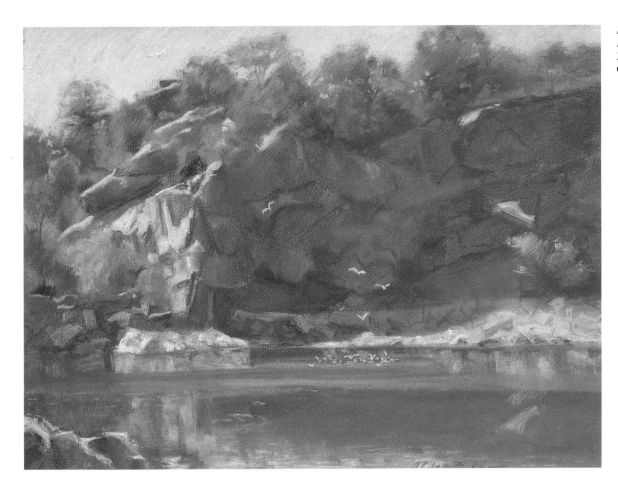

Alden Baker
Rockport Quarry
26" x 32" (66 cm x 81.3 cm)
Canson 75 lb. pastel paper

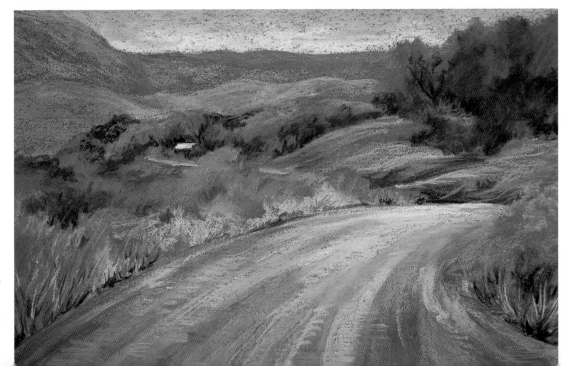

Dorothy Davis Thompson
Beyond the Bend
11" x 17" (27.9 cm x 43.2 cm)
Canson Mi-Teintes dark
grayish blue paper

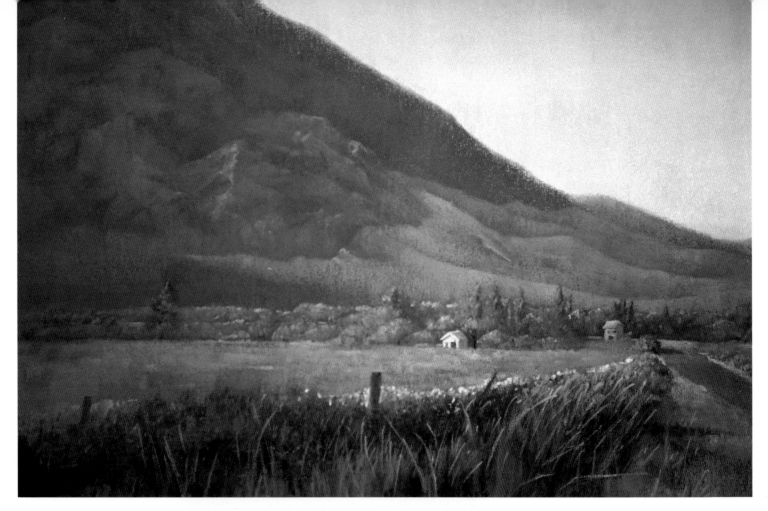

Flavia Monroe
Pleasant Valley
20" x 26"
(51.4 cm x 66.8 cm)
Pastel cloth

Al Lachman
Blowing Cool
30" x 30" (76.2 cm x 76.2 cm)
Pastel with gesso
Rising museum board

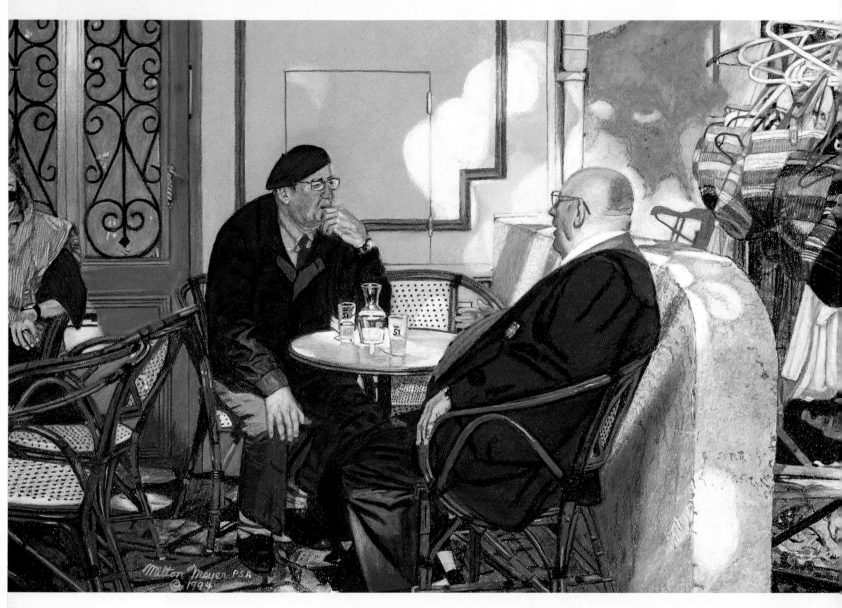

Milton Meyer
Differing Views of Time - Pastis Drinkers in Provence
11" x 16.5" (27.9 cm x 41.9 cm)
Canson Mi-Teintes pastel paper

Milton Meyer
Boats of Honfleur
24" x 31" (61 cm x 78.5 cm)
Canson Mi-Teintes paper

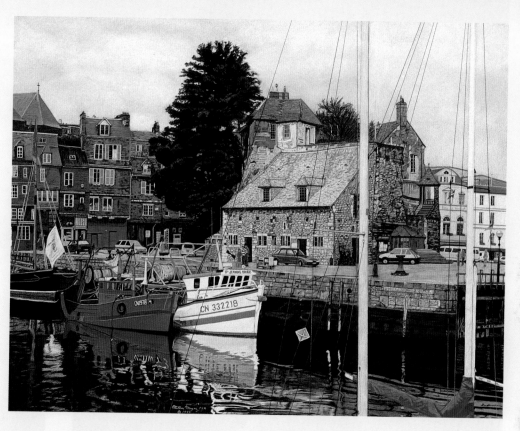

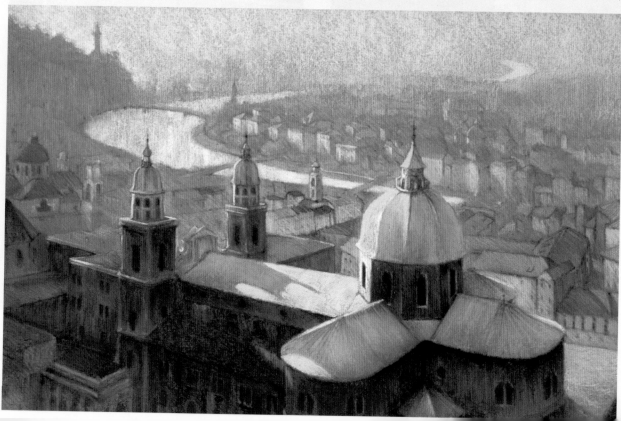

Margot S. Schulzke
Salzburg Afternoon
23" x 33" (58.4 cm x 83.8 cm)
Sabretooth 2-ply rag board

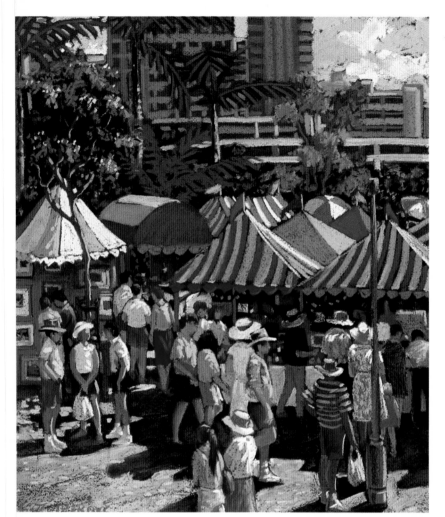

Christine F. Atkins
Sunday Morning Markets
16" x 13" (40.6 cm x 33 cm)
Canson Mi-Teintes pastel paper

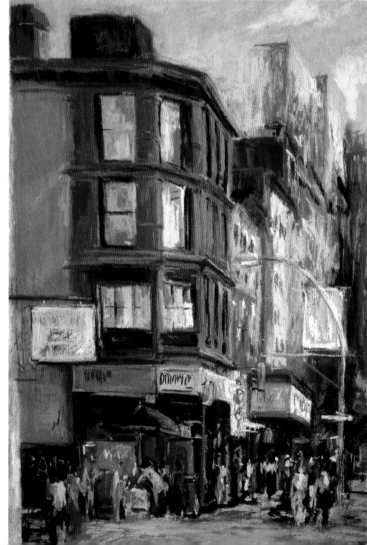

Lorrie B. Turner
Going About Business
28" x 20" (71.1 cm x 50.8 cm)
Pastel with gesso and acrylic
Gesso-, pumice- and acrylic-
textured 100% rag acid-free
hand-made museum board

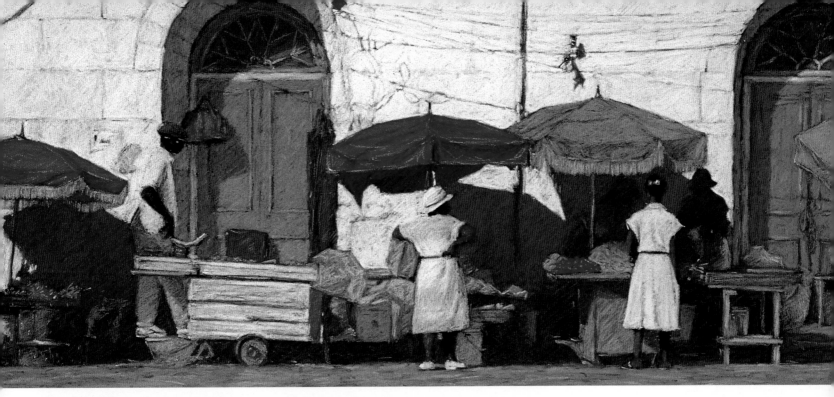

Alice Bach Hyde
Bridgetown Market, Barbados
16" x 34.5" (40.6 cm x 87.6 cm)
Canvas made for pastels

Desmond O'Hagan
Conversation, Verona
18" x 22" (45.7 cm x 55.9 cm)
Canson Mi-Teintes paper

Harvey Dinnerstein
Morning Light, Brooklyn
17.75" x 22.5" (45.1 cm x 57.2 cm)
Board

Wendy Goldberg
Larkspur: 3 PM
18" x 14" (45.7 cm x 35.6 cm)
Acid-free brown-toned 140 lb. paper

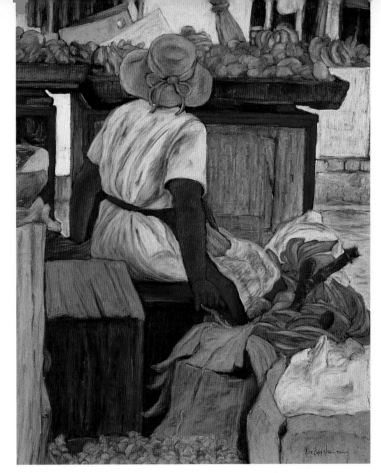

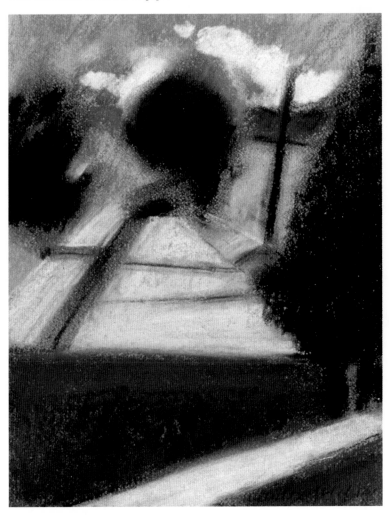

Alice Bach Hyde
Plantains and Peppers
27" x 21.5" (69.2 cm x 54.6 cm)
Ersta Starcke 7/0 grit pastel
sandpaper

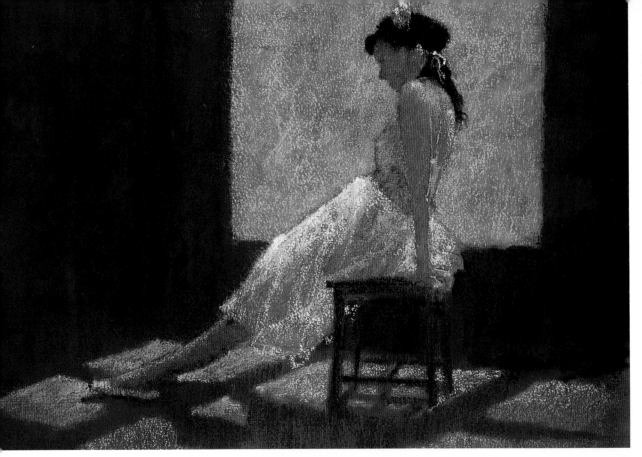

Lilienne B. Emrich
Repose
9" x 13" (22.9 cm x 33 cm)
Pumice-toned art board

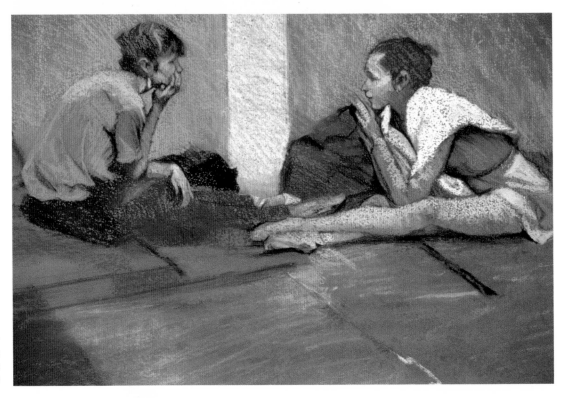

Rhoda Yanow
The Conversation
22" x 28" (55.9 cm x 71.1 cm)
Sanded surface

Joann A. Ballinger
In the Light
11" x 7" (27.9 cm x 17.8 cm)
Sandpaper

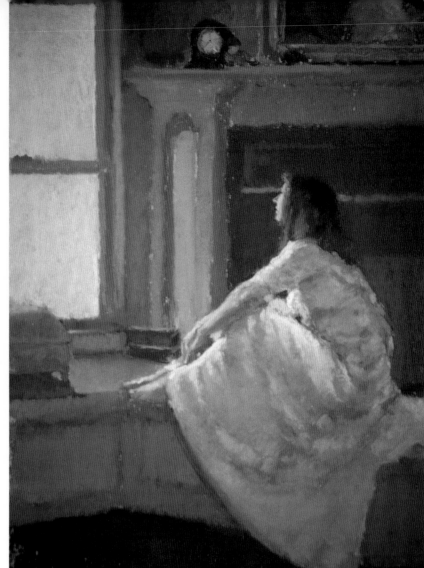

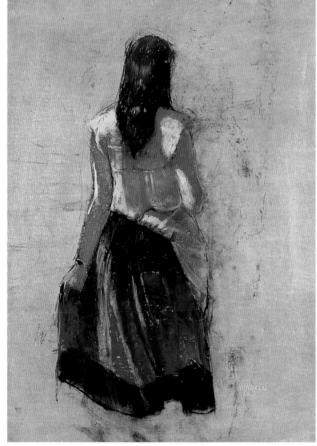

Albert Handell
Patra
22" x 16" (55.9 cm x 40.6 cm)
Sanded pastel board

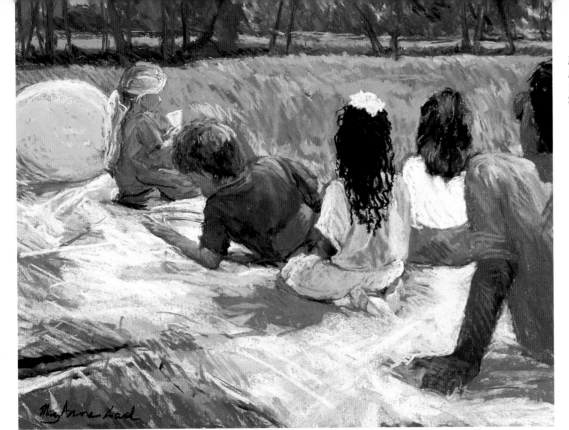

Mary Anne Lard
Listening
13" x 17" (33 cm x 43.2 cm)
Sanded paper

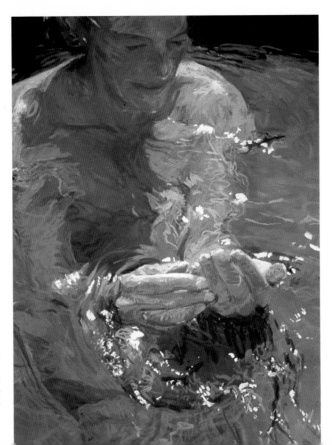

Kitty Wallis
Hot Tub #11
42" x 40" (106.7 cm x 101.6 cm)
Pastel with acrylic-wash underpainting
Sandpaper

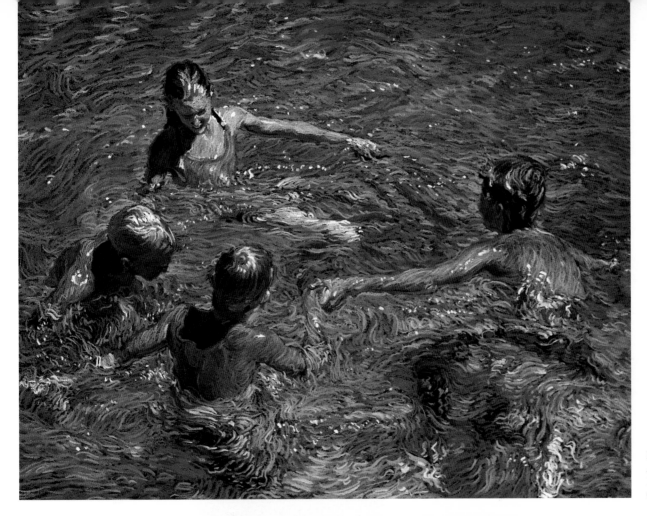

Bill James
Kids in Pool
19" x 22" (48.3 cm x 55.9 cm)
Canson Mi-Teintes paper

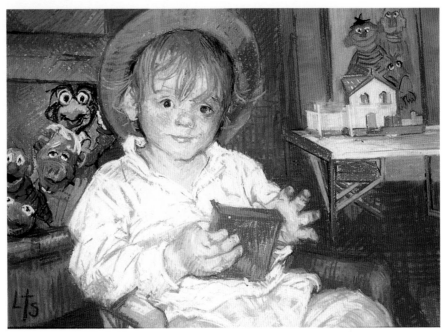

Lucille T. Stillman
Richard Peter
20" x 25" (50.8 cm x 63.5 cm)
Canson Mi-Teintes paper

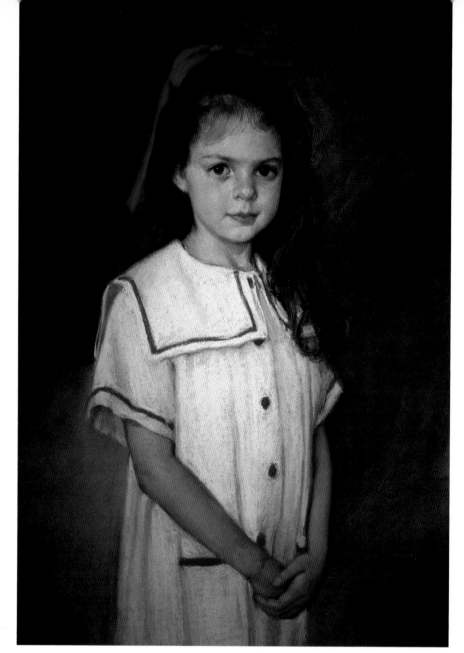

Mitsuno Ishii Reedy
Claire
24" x 20" (61 cm x 50.8 cm)
Canson Mi-Teintes paper

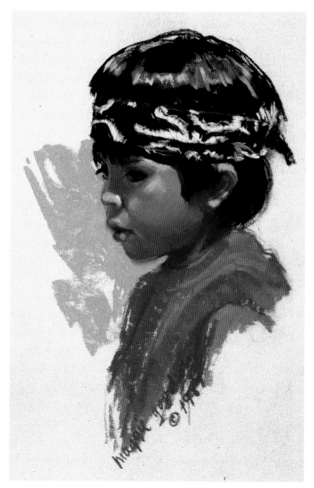

Maggie Goodwin
Navajo Boy
10" x 7" (25.4 cm x 17.8 cm)
Ersta paper

Charlotte Wharton
Little Boy Blue
21" x 15" (53.3 cm x 38.1 cm)
Canson paper

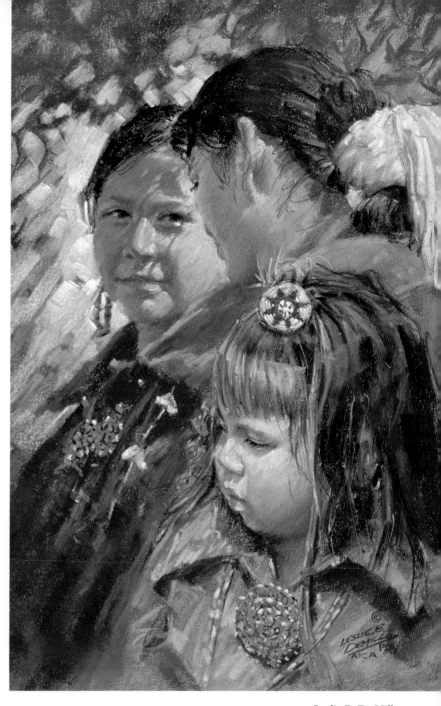

Leslie B. De Mille
#1620 Teen Secrets
23.5" x 16" (59.7 cm x 40.6 cm)
Canson paper

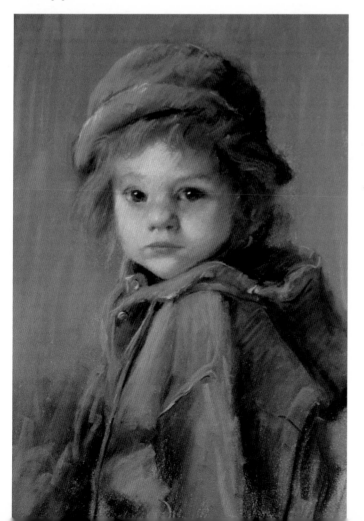

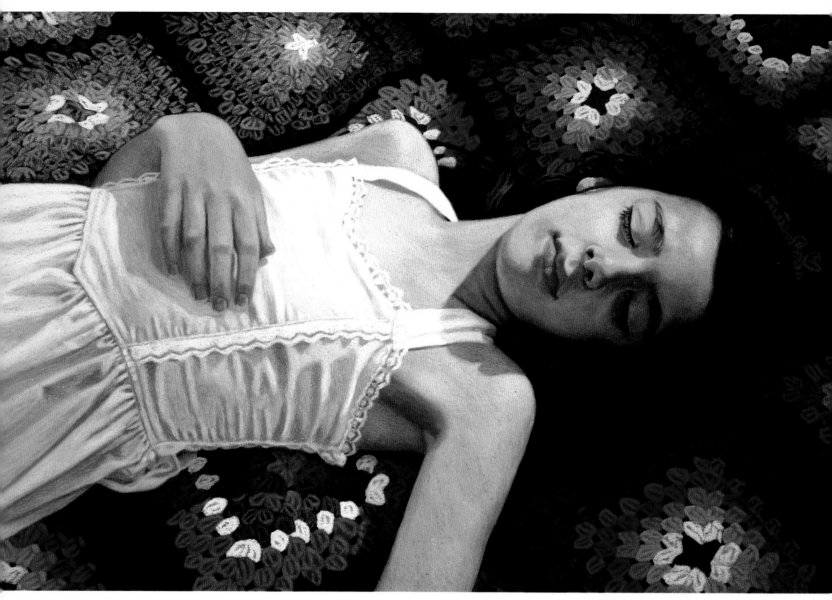

Toni Lindahl
Repose
20" x 30" (50.8 cm x 76.5 cm)
Arches 140 lb. watercolor paper

Parima Parineh
Untitled (2)
25" x 20" (63.5 cm x 50.8 cm)
Canson Mi-Teintes paper

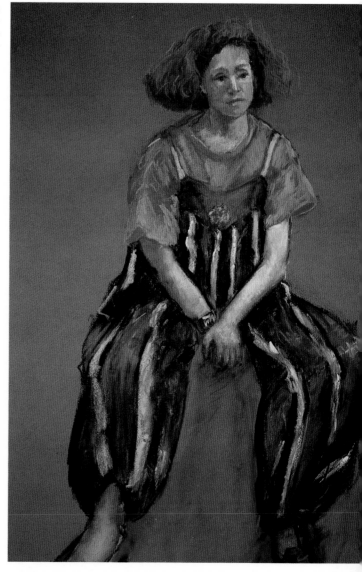

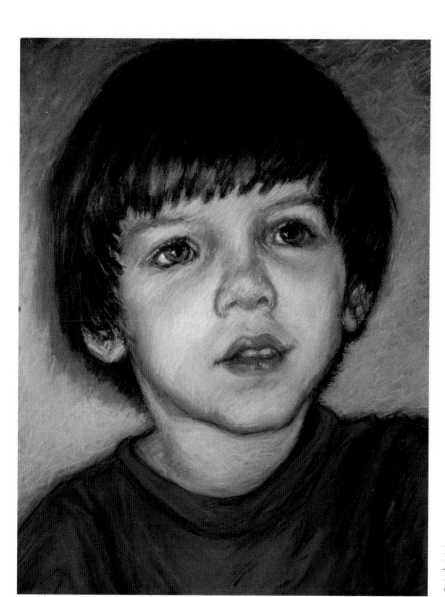

Beatrice Goldfine
Joey
25.5" x 19.5" (64.8 cm x 49.5 cm)
Canson pastel paper

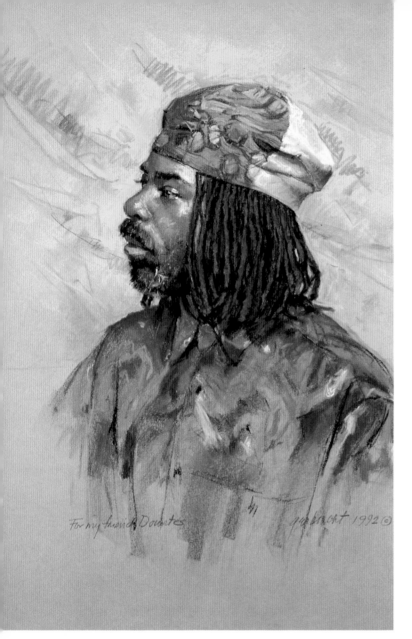

Bob Gerbracht
Dountes
25" x 19" (63.5 cm x 48.3 cm)
Canson Mi-Teintes 75 lb. paper

Mary Gayle Shanahan
Renaissance Fair
22" x 16" (55.9 cm x 40.6 cm)
Canson Mi-Teintes gray paper

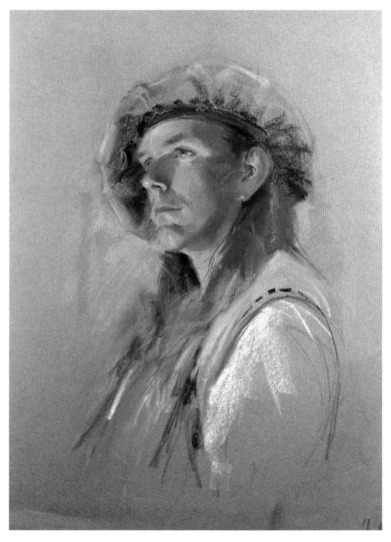

Janis Theodore
Young Man/Old Map © 1993
28" x 22" (71.1 cm x 55.9 cm)
Pastel sandpaper

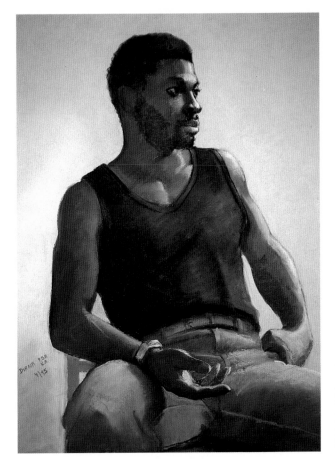

Diana De Santis
Tyrone
36" x 28" (91.4 cm x 71.1 cm)
Gesso-primed Arches 4-ply
board

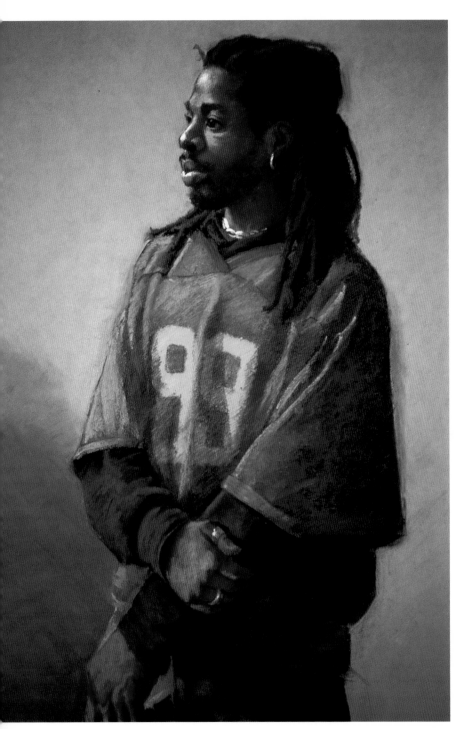

Diana De Santis
Renee 99
36" x 28" (91.4 cm x 71.1 cm)
Gesso-primed Arches 4-ply board

Rhoda Yanow
Rehearsal
26" x 22" (66 cm x 55.9 cm)
Sanded surface

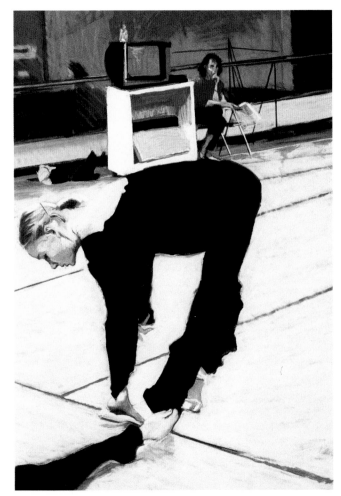

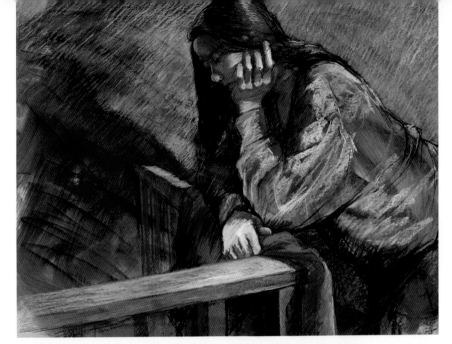

Junko Ono Rothwell
Looking Over the Bannister
21" x 27" (53.3 cm x 68.6 cm)
Pastel with turpentine
German sanded pastel paper

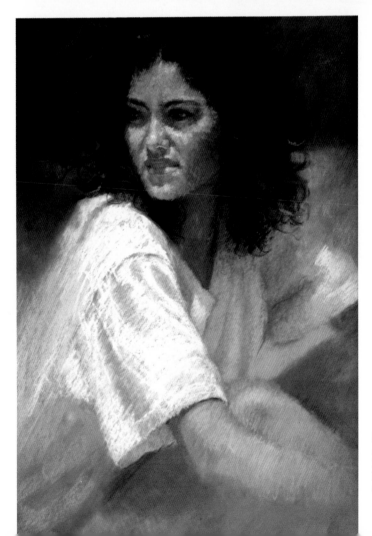

Sandra A. Johnson
Isa
36" x 28" (91.4 cm x 71.1 cm)
Pastel with turpentine
Canson pastel paper

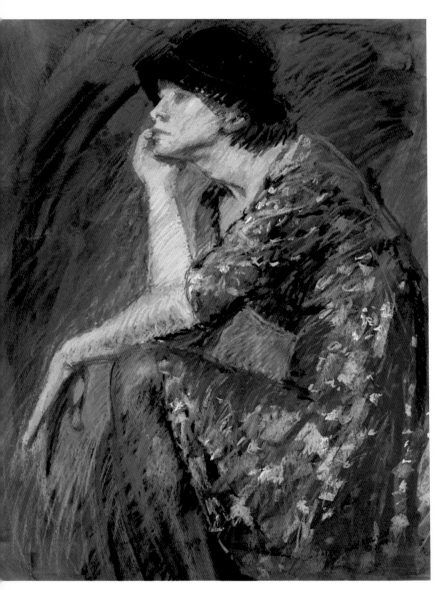

Mikki R. Dillon
The Flowered Dress
27" x 21" (68.6 cm x 53.3 cm)
Ersta sanded paper

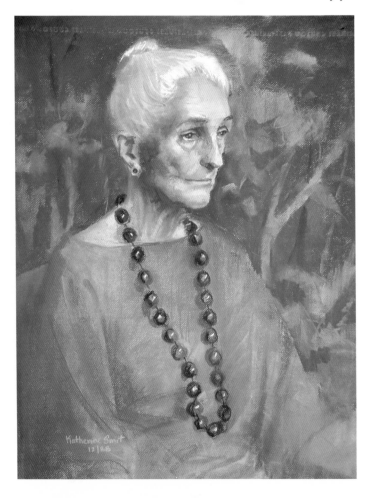

Katherine Smit
Bea
30" x 24" (76.2 cm x 61 cm)
Canson Mi-Teintes paper

Mary Poulos
Laurie
30" x 22" (76.2 cm x 55.9 cm)
Canson Mi-Teintes dark gray
paper

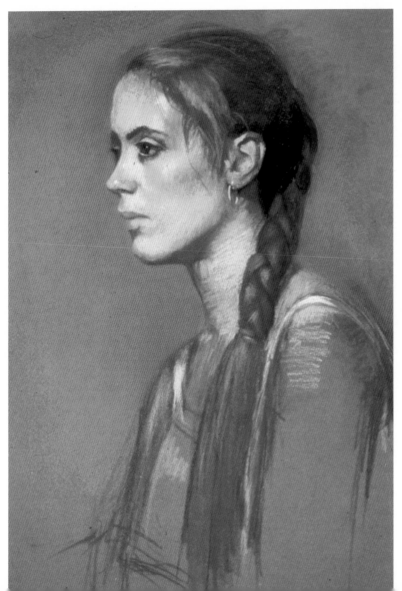

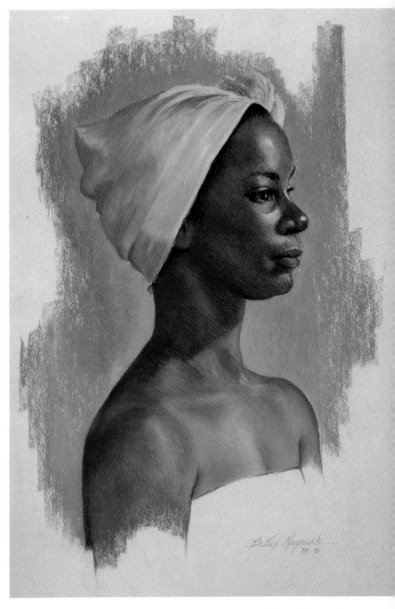

Bettey Naymark
Lita
24" x 18" (61 cm x 45.7 cm)
Canson paper

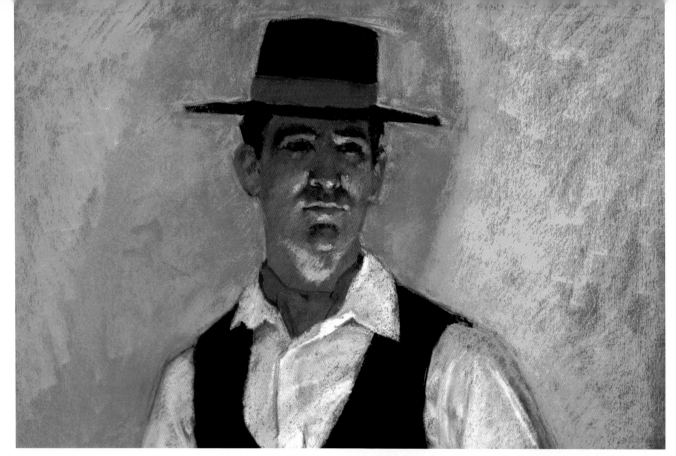

Bob Gerbracht
The Flamenco Dancer
13" x 19" (33 cm x 48.3 cm)
Canson Mi-Teintes 75 lb. paper

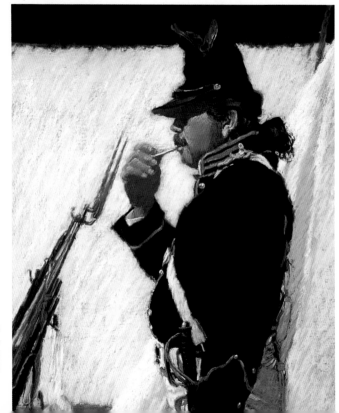

Bill James
Heritage Day
19" x 16" (48.3 cm x 40.6 cm)
Pumice board

Phyllis J. Friel
Iron Eagle
17" x 13" (43.2 cm x 33 cm)
007 Sanded paper

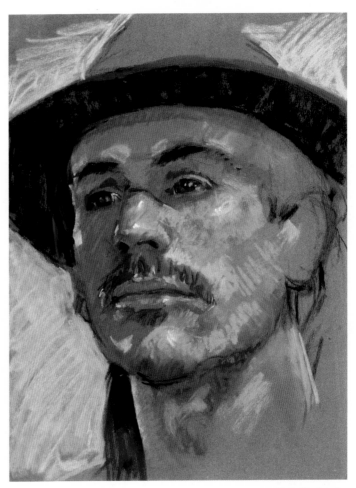

Bob Gerbracht
Color Pleasure
13" x 10" (33 cm x 25.4 cm)
Sennelier La Carte paper

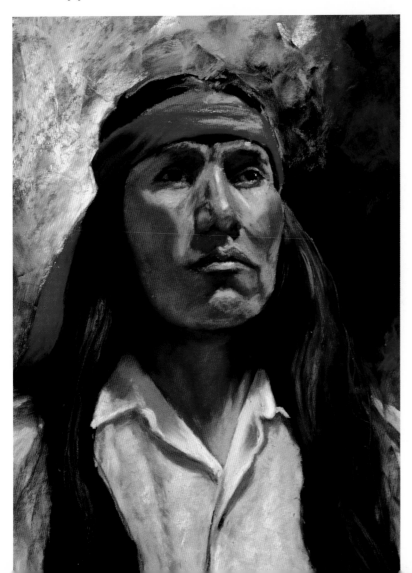

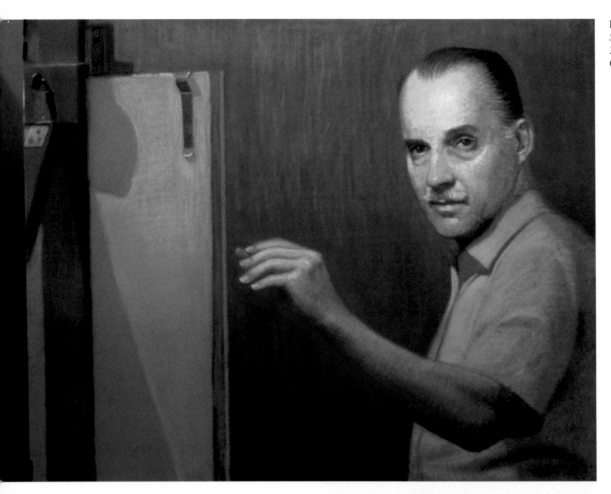

Dan Slapo
Self-Portrait at Easel
20" x 24" (50.8 cm x 61 cm)
Canson pastel paper

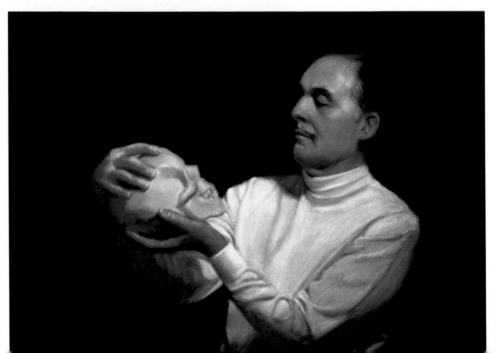

Dan Slapo
Alas, Poor Yorick
9.5" x 12.5" (24.1 cm x 31.8 cm)
Sennelier La Carte pastel board

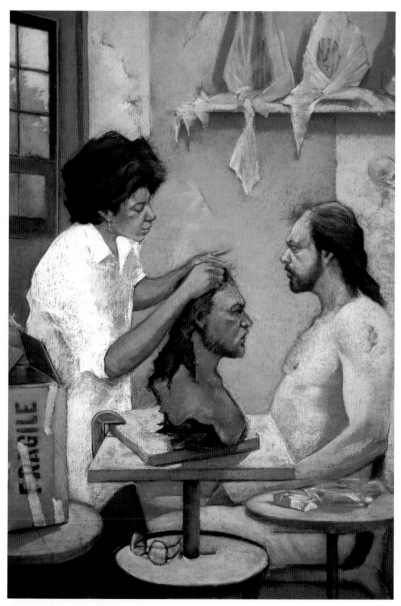

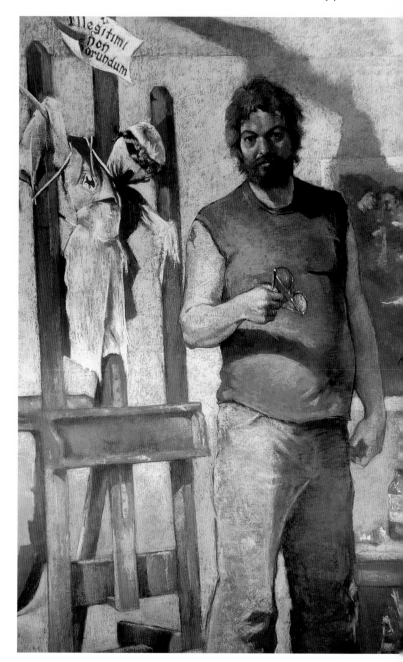

Alexander C. Piccirillo
The Effigy
65" x 45" (165.1 cm x 114.3 cm)
Pastel with gesso and ground pumice stone
Luan plywood

Alexander C. Piccirillo
Three Part Harmony
62" x 40" (157.5 cm x 101.6 cm)
Pastel with gesso and ground pumice stone
Triple-weight cold press illustration board

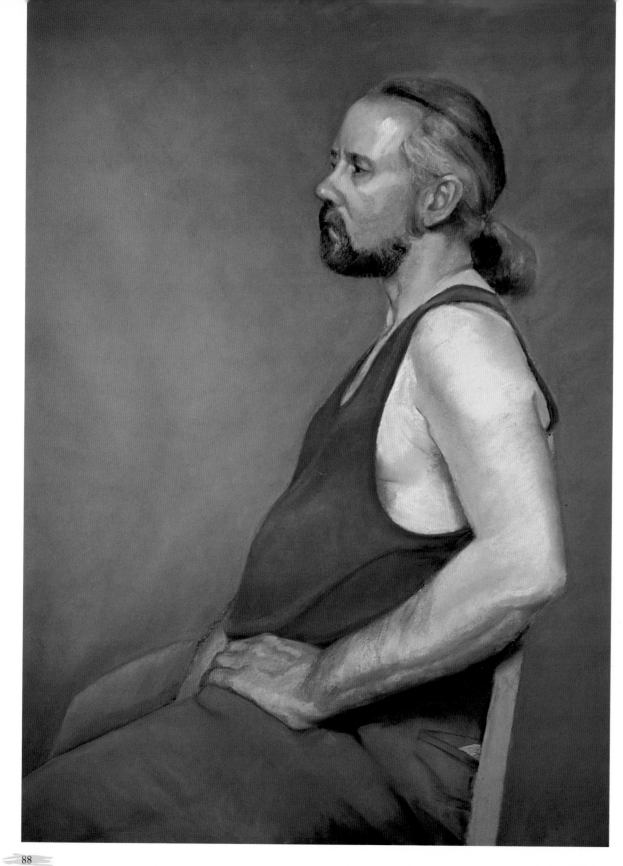

Diana De Santis
Marshall
36" x 28" (91.4 cm x 71.1 cm)
Gesso-primed Arches 4-ply board

S.S. Pennell
Cello
42" x 26" (106.7 cm x 66 cm)
Canson Mi-Teintes 108 lb. paper

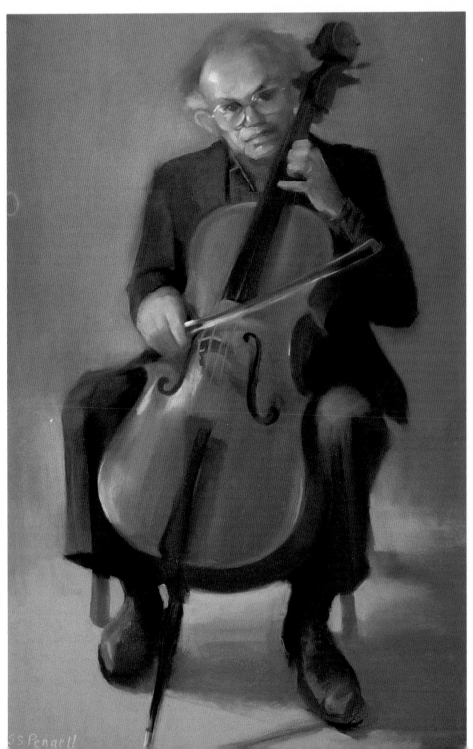

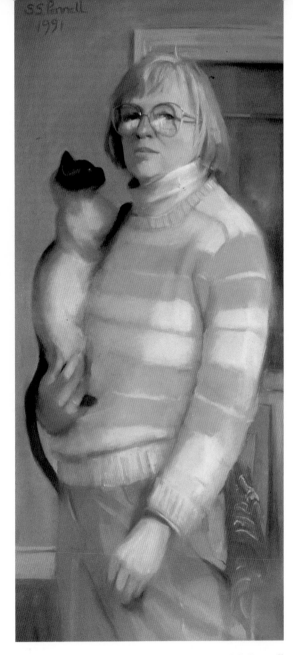

S.S. Pennell
SSP91
43" x 20" (109.2 cm x 50.8 cm)
Canson Mi-Teintes 108 lb. paper

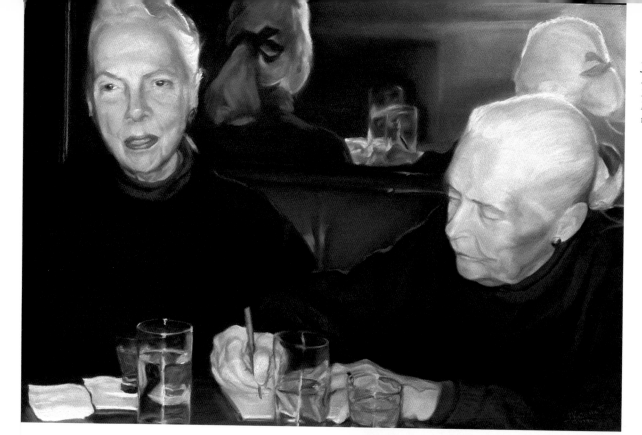

Jeanette V. Collett
Memoirs
24" x 36" (61 cm x 91.4 cm)
Marble-dust treated Windberg
masonite panel

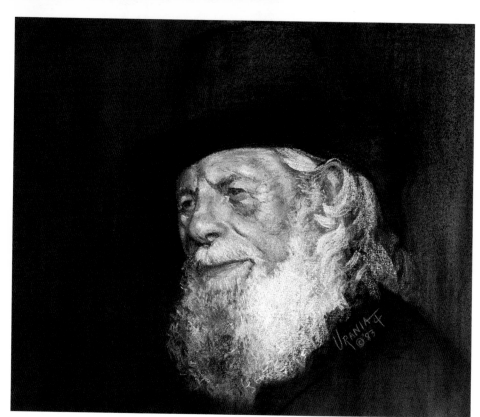

Urania Christy Tarbet
The Circuit Judge
24" x 30" (61 cm x 76.2 cm)
Gesso-primed canvas laminated on masonite

Barry G. Pitts
Storyteller in White
31" x 17.5" (78.7 cm x 44.5 cm)
Sanded board

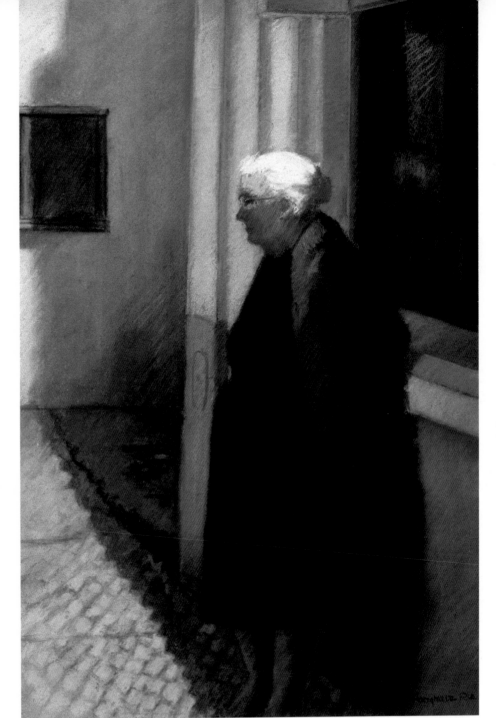

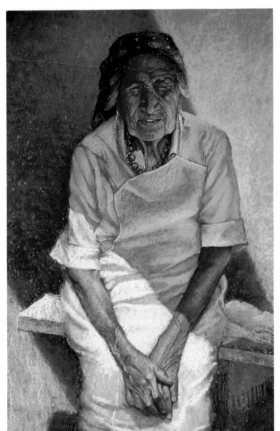

Mary Hargrave
The Fisherman's Widow, Navare, Portugal
23" x 17" (58.4 cm x 43.2 cm)
Canson Mi-Teintes paper

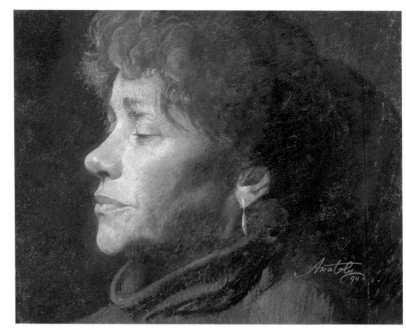

Anatoly Dverin
Clementine
15.5" x 19.5" (39.4 cm x 49.5 cm)
Canson Ingres pastel paper, tint #55

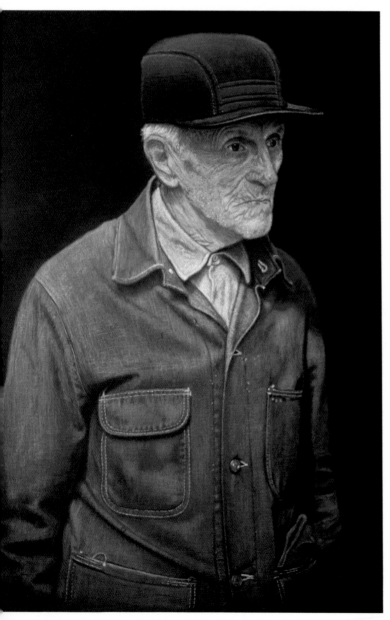

James E. Welch
Lee of Hartland
30" x 24" (76.2 cm x 61 cm)
Acid-free heavyweight paper

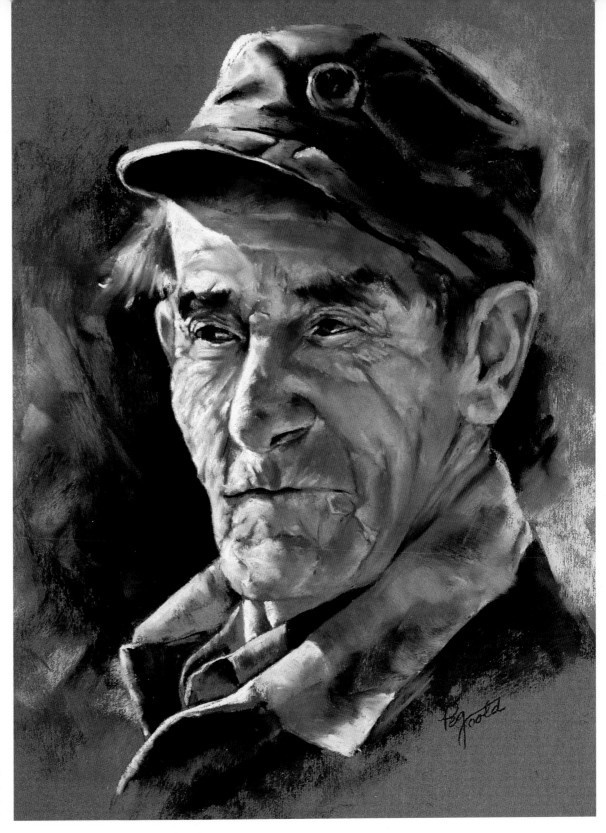

Peggy Ann Solinsky
Romero
19.5" x 16.5" (49.5 cm x 41.9 cm)
Sanded board

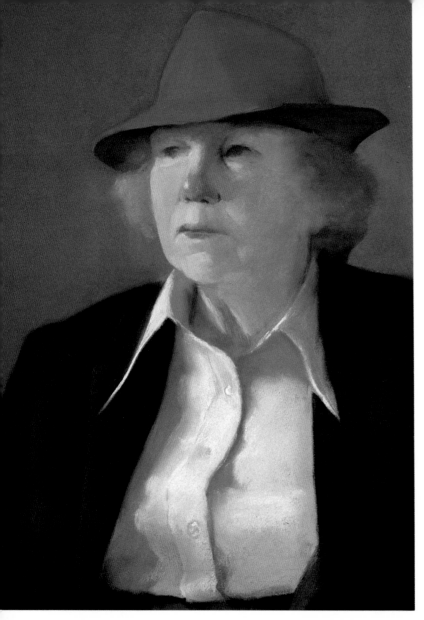

S.S. Pennell
The Professor
22" x 18" (55.9 cm x 45.7 cm)
Canson Mi-Teintes 108 lb. paper

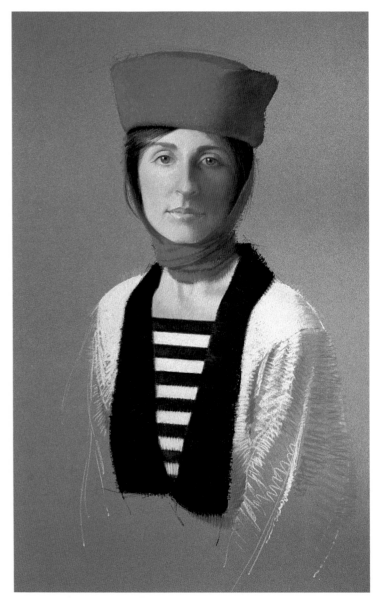

Neil Drevitson
Portrait of Artist's Wife
36" x 26" (91.4 cm x 66 cm)
Sanded panel

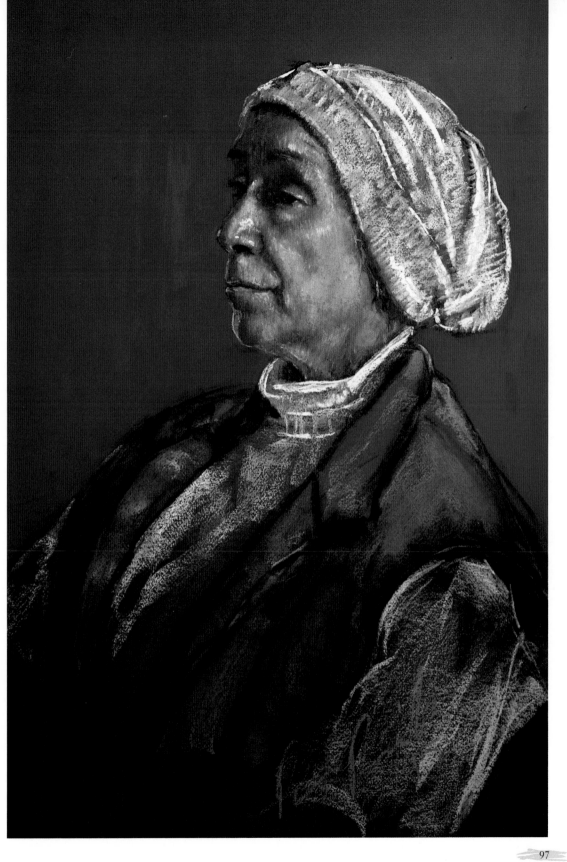

Parima Parineh
Grandmother
25" x 20" (63.5 cm x 50.8 cm)
Canson Mi-Teintes paper

Claire Schroeven Verbiest
Man in Sunlight
23" x 17" (58.4 cm x 43.2 cm)
Pastel with watercolor
Canson Mi-Teintes 75 lb. orange paper

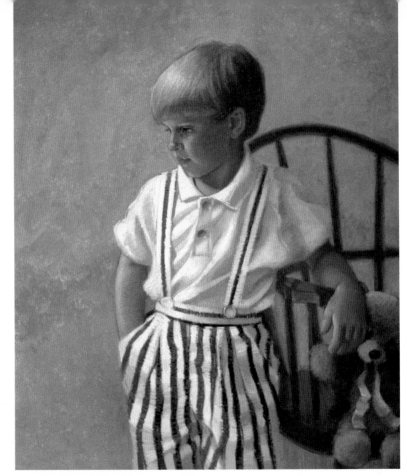

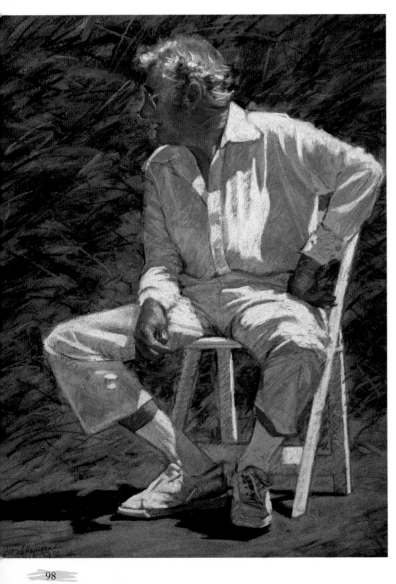

Ann Boyer Lepere
Portrait of John
30" x 25" (76.2 cm x 63.5 cm)
Gesso- and pumice-treated 4-ply
100% rag board

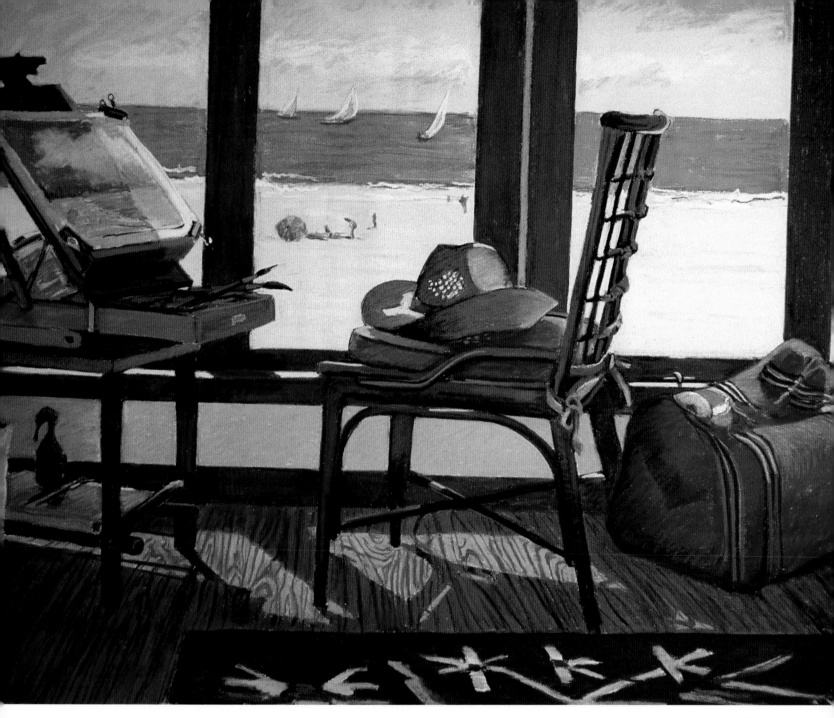

Martha Bator
A View from the Window
30" x 40" (76.2 cm x 101.6 cm)
Pastel cloth

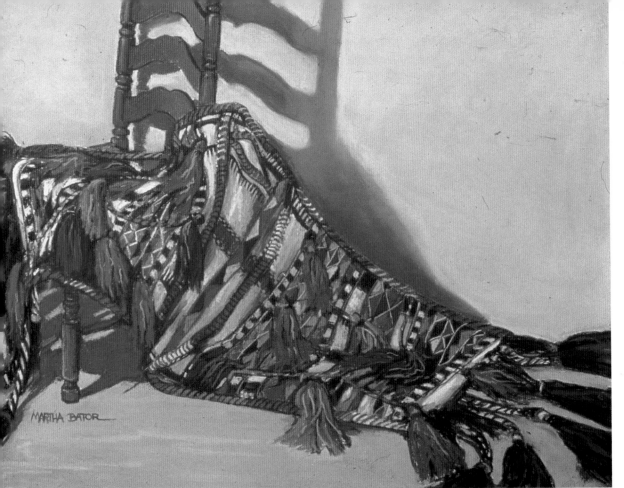

Martha Bator
The Red Chair
30" x 40" (76.2 cm x 101.6 cm)
Gesso- and pumice-prepared
Luan board

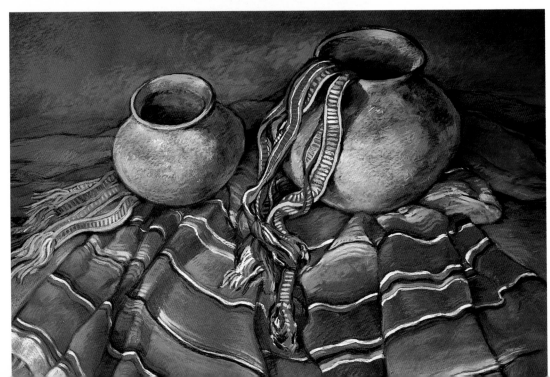

Marilee B. Campbell
Tarahumara Pots
20.5" x 27" (52.1 cm x 68.6cm)
Toned sanded paper

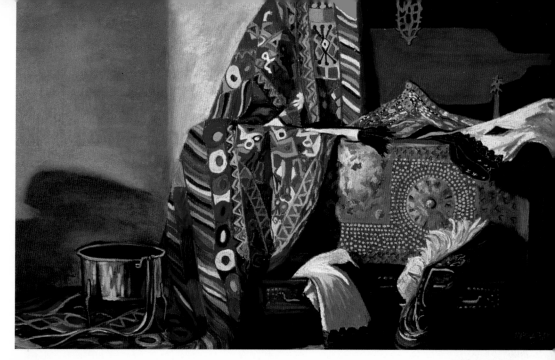

Martha Bator
Middle Eastern Mood
30" x 50" (76.2 cm x 127 cm)
Gesso- and pumice-prepared
Luan board

Janis Theodore
Cat with Indian Bird Blanket © 1989
30" x 22" (76.2 cm x 55.9 cm)
Rives BFK heavyweight paper

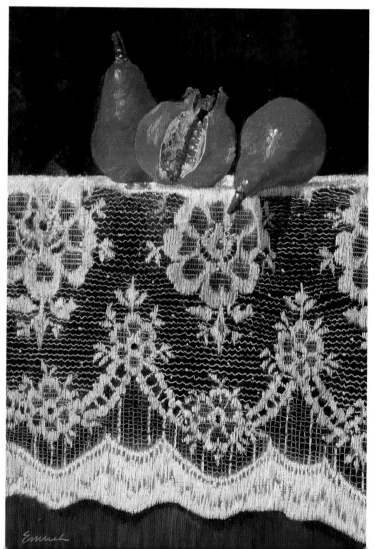

Lilienne B. Emrich
Red Pears and Pomegranate
25" x 16" (63.5 cm x 40.6 cm)
Pumice-toned art board

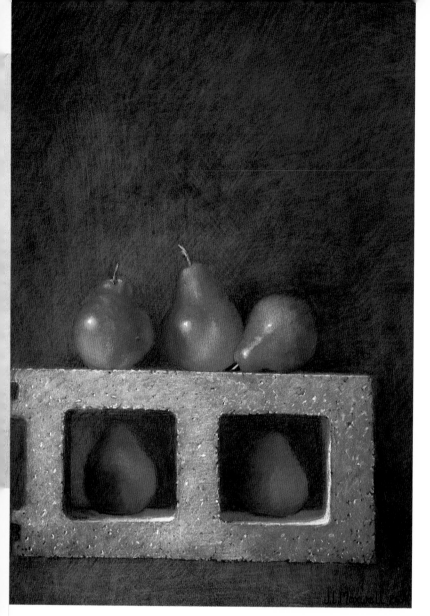

J.T. Maxwell
Cinderblock with Red Pears
22" x 16" (55.9 cm x 40.6 cm)
La Carte pastel board

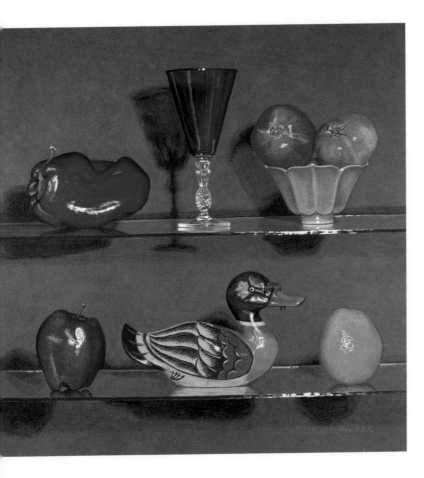
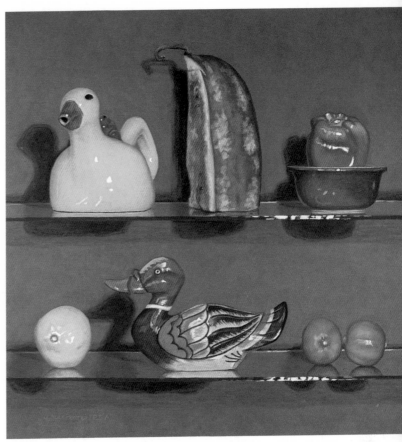

J. Alex Potter
Rainbow Coalition: Ducks Infiltrating (Diptych)
30" x 30" each panel (76.2 cm x 76.2 cm each panel)
Pastel cloth

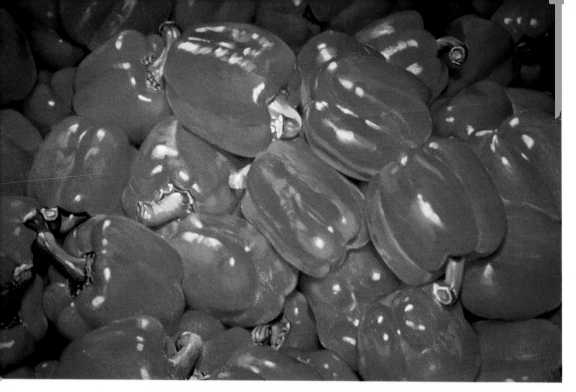

Roslyn Hollander
Red Peppers
19" x 29" (48.3 cm x 73.7 cm)
Arches paper

Roslyn Hollander
Bunches of Broccoli
24" x 34" (61 cm x 86.4 cm)
Sabretooth paper

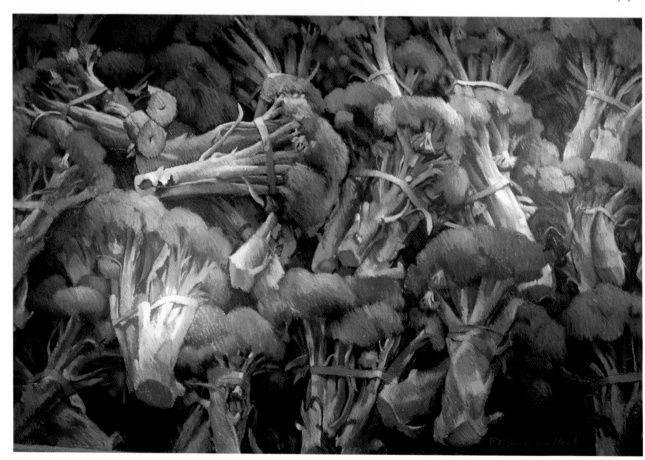

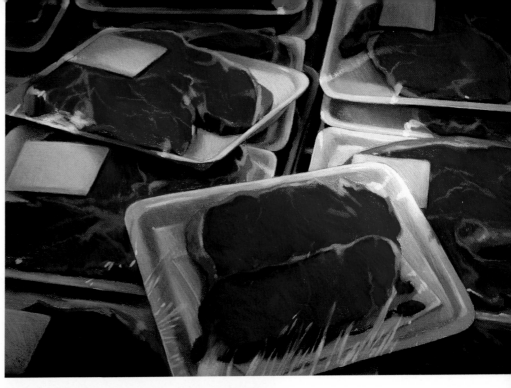

Roslyn Hollander
Choice Beef
21" x 28" (53.3 cm x 71.1 cm)
Arches paper

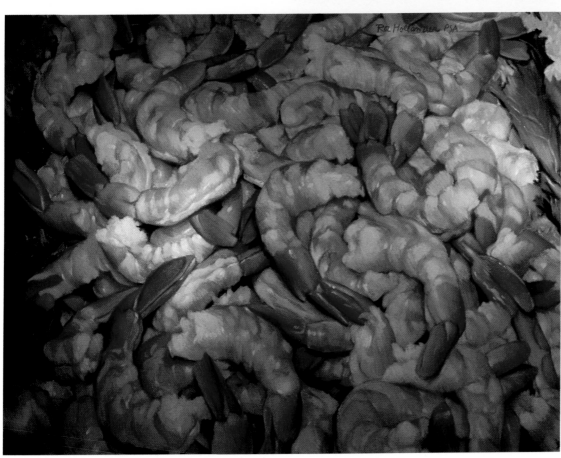

Roslyn Hollander
Jumbo Shrimp
21" x 28" (53.3 cm x 71.1 cm)
Rives BFK paper

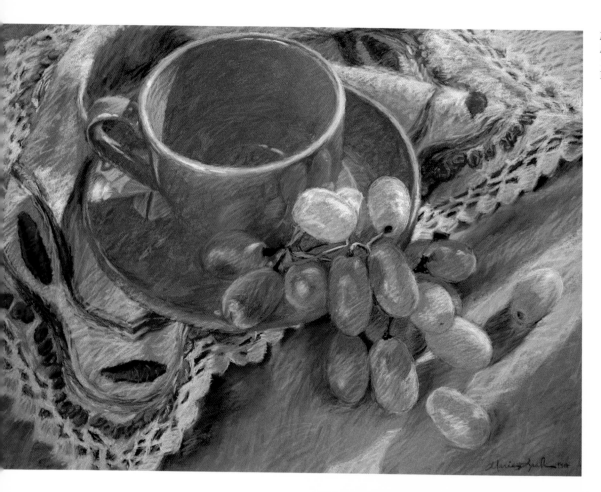

Marie Kash Weltzheimer
Pink Tea Cup II
17.5" x 24" (44.5 cm x 61 cm)
La Carte sanded pastel card

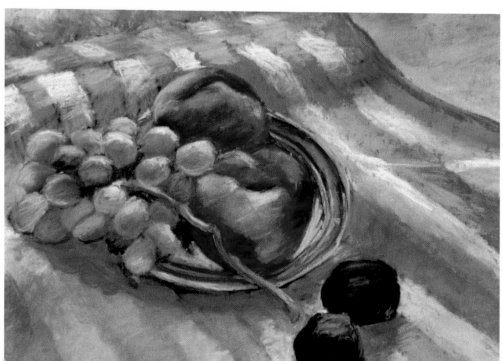

Evelyn Inman
Fruit on Striped Cloth
15" x 17" (38.1 cm x 43.2 cm)
Sanded pastel paper

Joan D. Macnaught
Still Life with Kettle
14" x 21" (35.6 cm x 53.4 cm)
Canson pastel paper

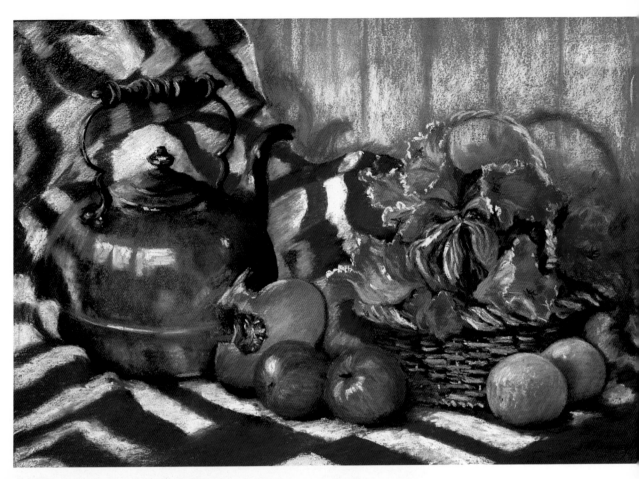

B.E. Hopkins
Modica Market
21" x 27" (53.3 cm x 68.6 cm)
Herman Margulies board

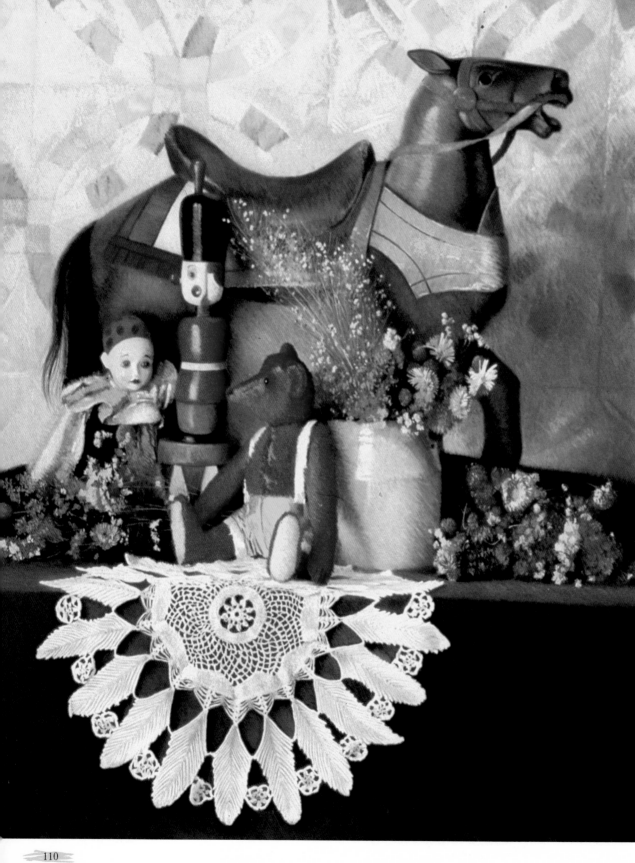

Janice Ann Drevitson
Victorian Memories
40" x 32" (101.6 cm x 81.3 cm)
Sanded panel

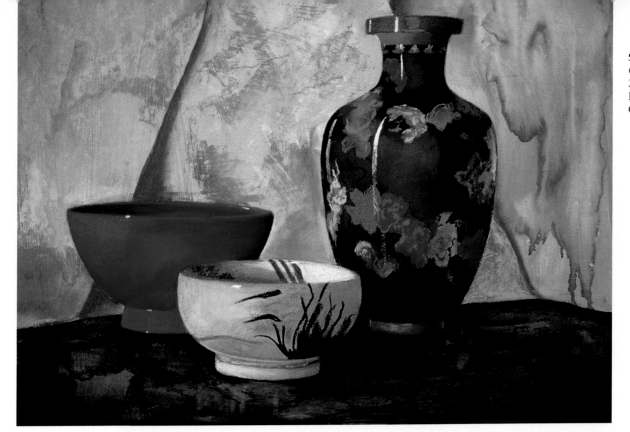

Susan Gerstein
Chinese Still Life
24" x 30" (61 cm x 76.2 cm)
Pastel with gouache
Gesso-primed masonite board

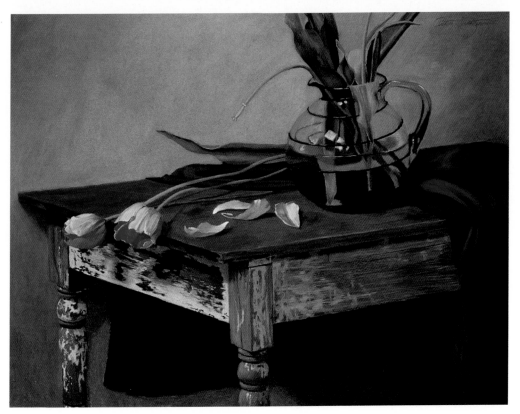

Peter Seltzer
May
29" x 34" (73.7 cm x 86.4 cm)
Canson Mi-Teintes paper

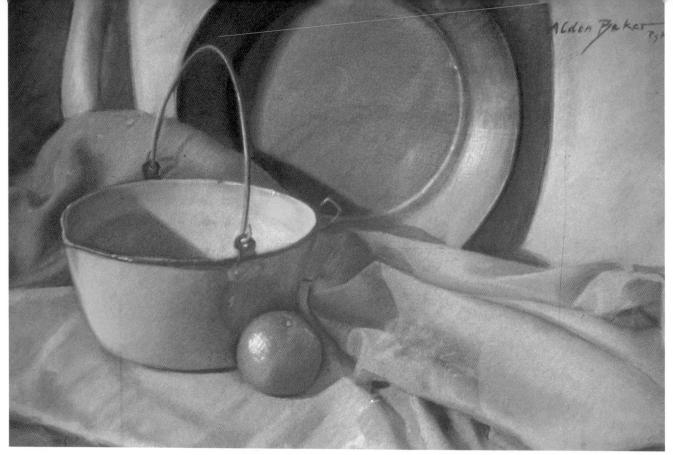

Alden Baker
The Brass Pan
27" x 37" (68.6 cm x 93.9 cm)
Canson pearl-gray paper

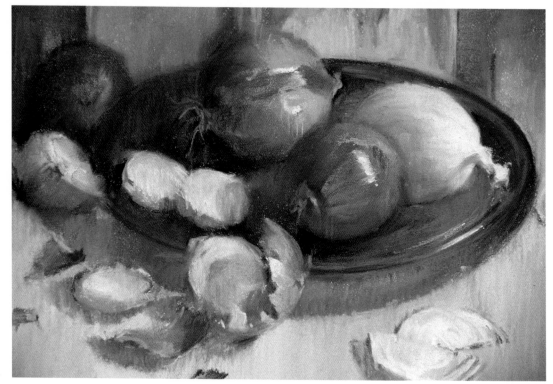

Faye Kazdal
Onion Plate
14" x 20" (35.6 cm x 50.8 cm)
Canson Mi-Teintes paper

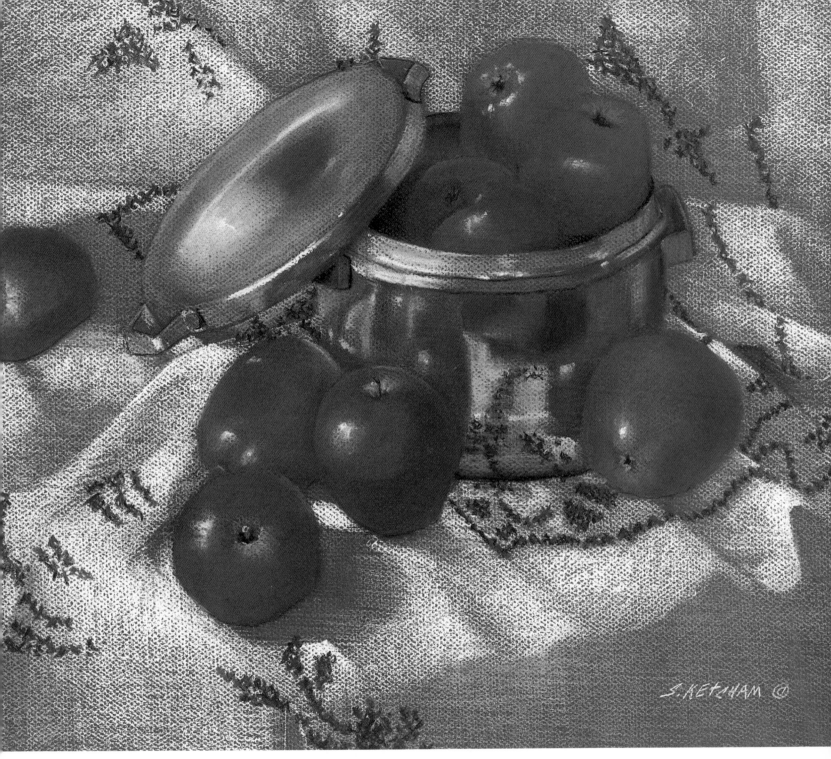

Susan H. Ketcham
Apples!!
15.5" x 19" (39.4 cm x 48.3 cm)
Canson Mi-Teintes 75 lb. paper

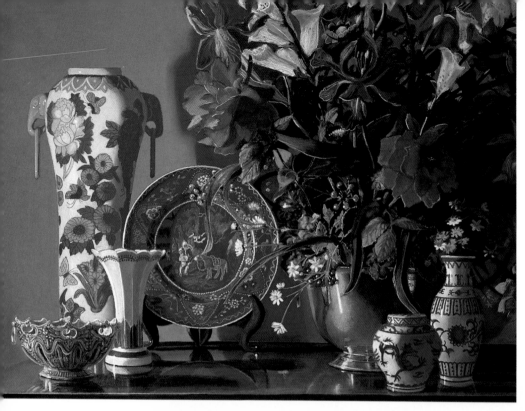

Patty Herscher
Porcelaine
32" x 40" (81.3 cm x 101.6 cm)
Pastel cloth

Patty Herscher
Jardin D'Hiver
32" x 40" (81.3 cm x 101.6 cm)
Pastel cloth

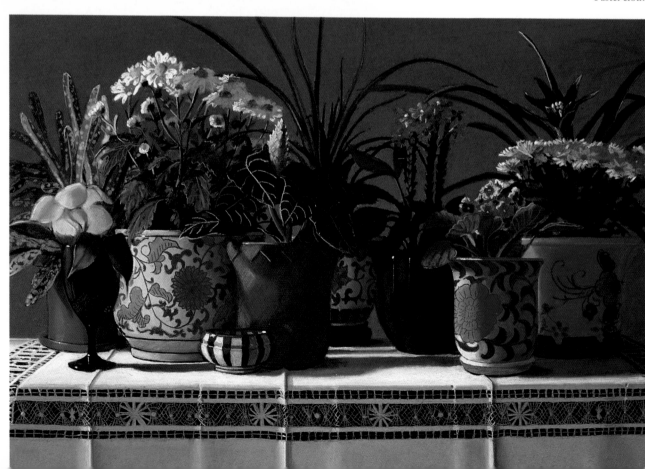

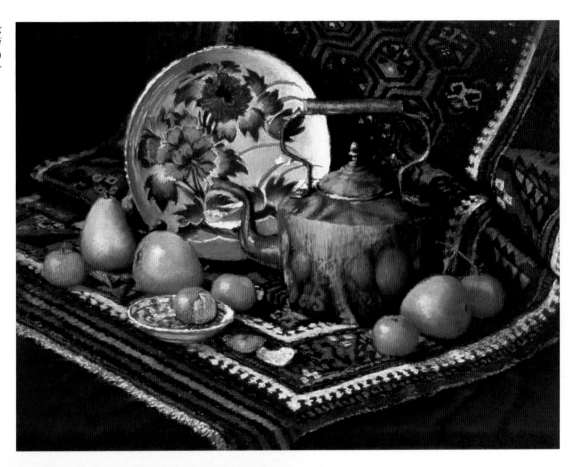

Susan E. Selig
Peony Plate with Copper Kettle on Baluchi
21" x 27" (52.7 cm x 67.6 cm)
Sanded paper

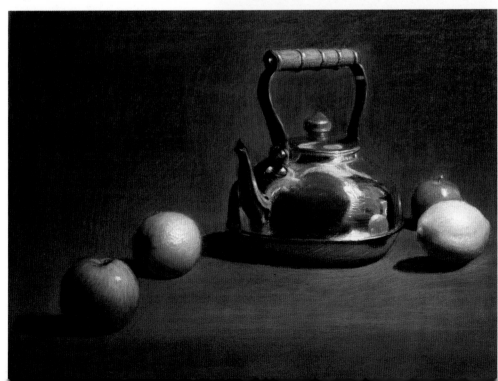

Daniel Slapo
Brass Kettle and Fruit
20" x 24" (50.8 cm x 61 cm)
Canson pastel paper

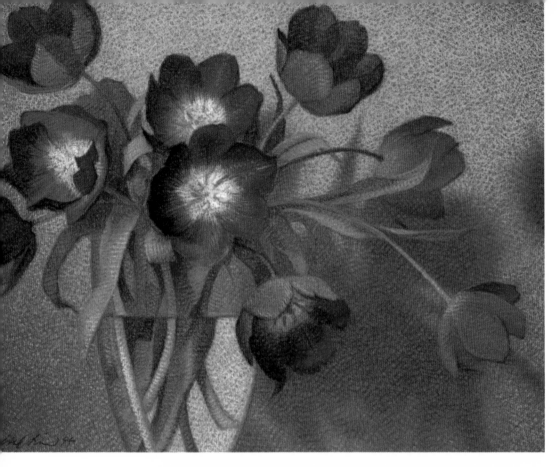

Makie Hino
Tulips
15" x 19" (38.1 cm x 48.4 cm)
Canson pastel paper

Georgiana Cray Bart
Yellow Mug with Black Mug: Listening
16.5" x 24.5" (41.9 cm x 62.2 cm)
Canson Mi-Teintes 75 lb. paper

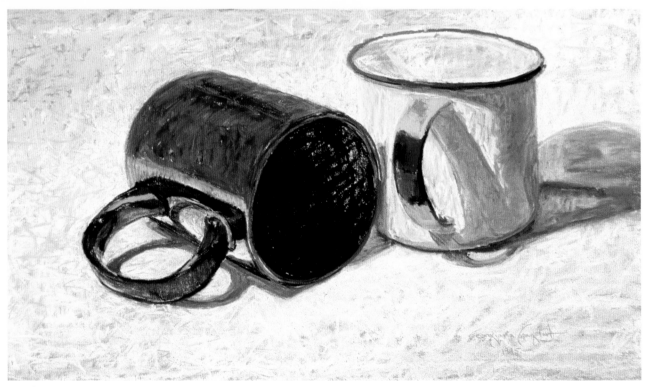

Georgiana Cray Bart
Yellow Mug with Yellow, Black and White Objects
31" x 19.5" (78.7 cm x 49.5 cm)
Canson Mi-Teintes 75 lb. paper

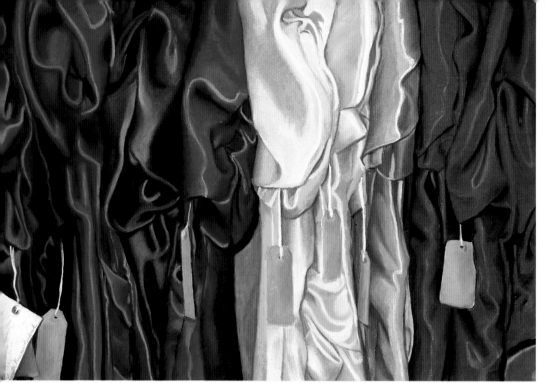

Loreta Kreeger Feeback
Adorning Hue
21" x 27" (53.3 cm x 68.6 cm)
Sanded pastel paper

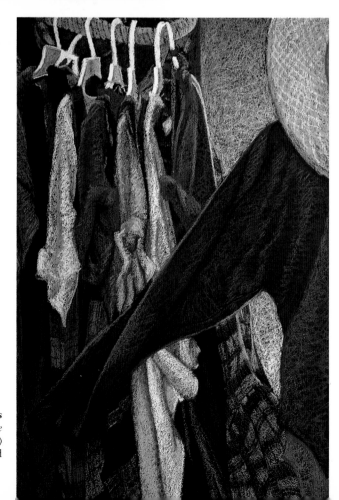

B.E. Hopkins
Green Sleeve
38" x 31" (96.5 cm x 78.7 cm)
Herman Margulies board

Peter Seltzer
Deep Breakfast
25" x 19" (63.5 cm x 48.3 cm)
Sennelier La Carte pastel paper

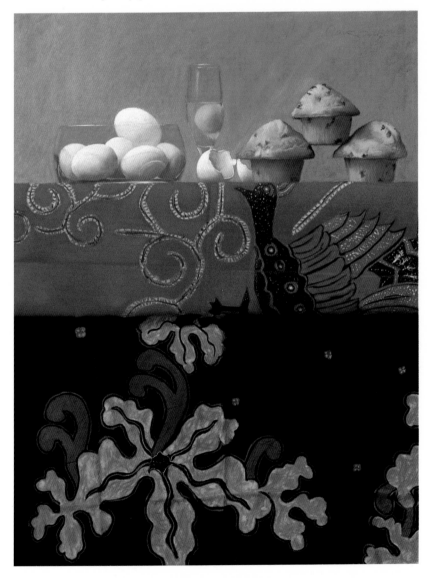

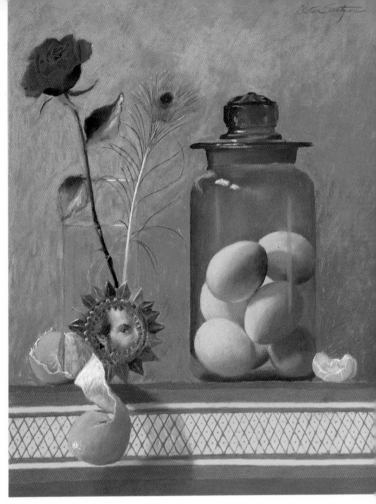

Peter Seltzer
The "I" of the Beholder
20" x 16" (50.8 cm x 40.6 cm)
Sennelier La Carte pastel paper

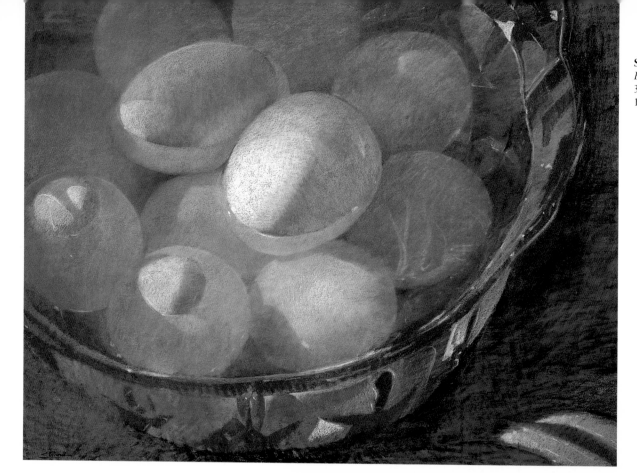

Sally Strand
Eggs Underwater
36" x 48.5" (91.4 cm x 123.2 cm)
140 lb. Cold press watercolor paper

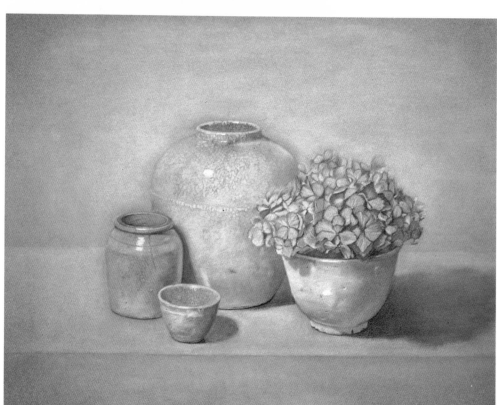

Elsie Eastman
Four Pale Pots
19" x 24" (48.2 cm x 61 cm)
Canson Mi-Teintes paper

J.T. Maxwell
Mason Jar with Eggs
19.5" x 14.5" (49.5 cm x 36.8 cm)
La Carte pastel board

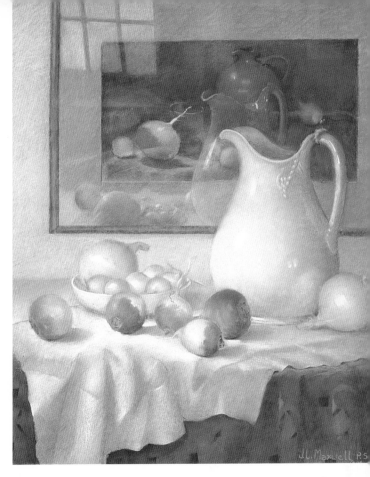

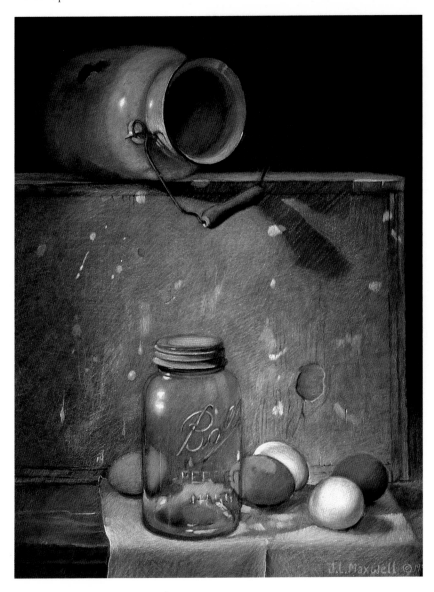

J.T. Maxwell
Reflections
29" x 26" (73.7 cm x 66 cm)
La Carte pastel board

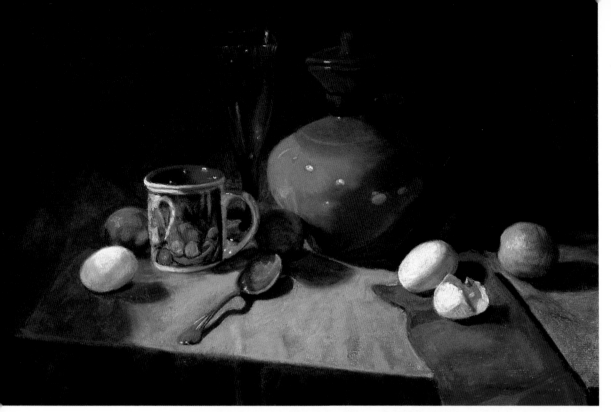

Muriel Hughes
Cézanne Brunch
17.5" x 24" (44.5 cm x 61 cm)
Gesso- and pumice-coated 300 lb.
watercolor paper

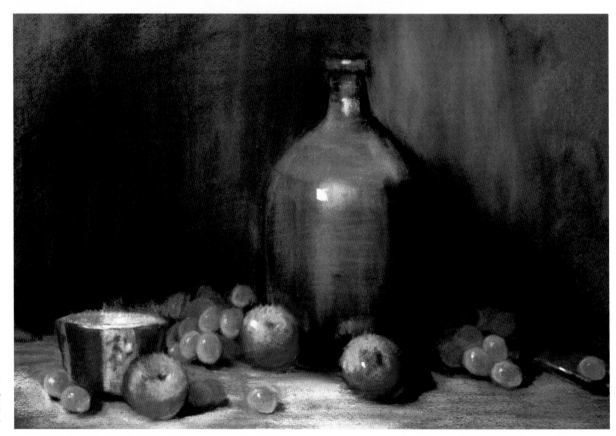

Mary Hargrave
The Brown Jug
14" x 18" (35.6 cm x 45.7 cm)
Canson Mi-Teintes paper

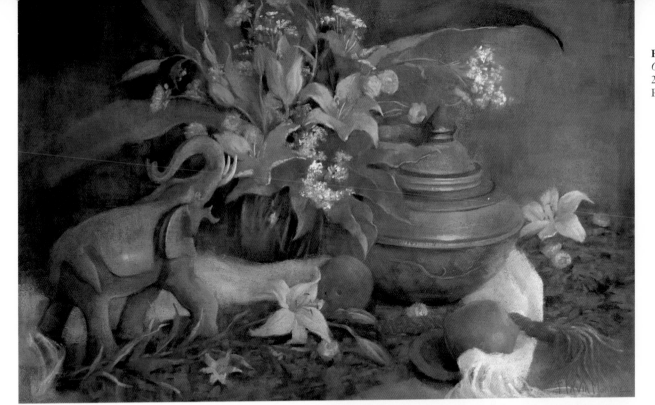

Flavia Monroe
Orange Lillies
24" x 36" (61 cm x 91.4 cm)
Pastel cloth

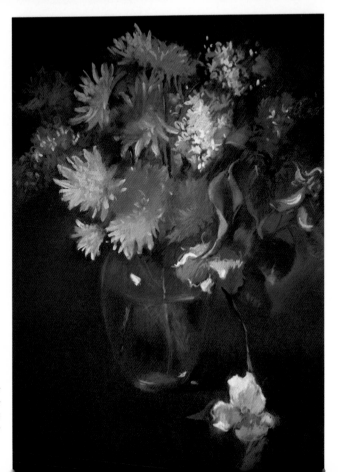

Christina Debarry
Mixed Bouquet
19" x 13" (48.3 cm x 33 cm)
Sanded pastel paper

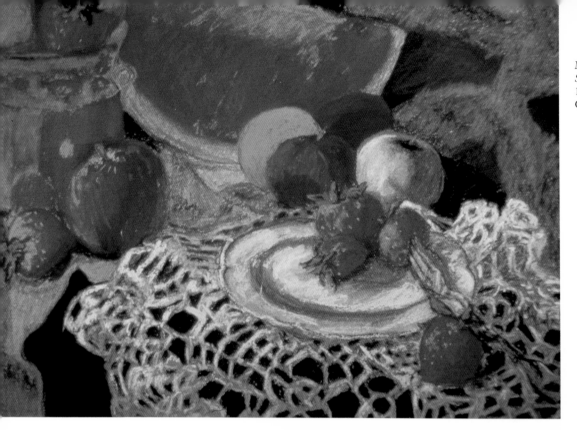

Mary Jane Manford
Seedless Watermelon
15" x 21" (38.1 cm x 53.3 cm)
Canson Mi-Teintes paper

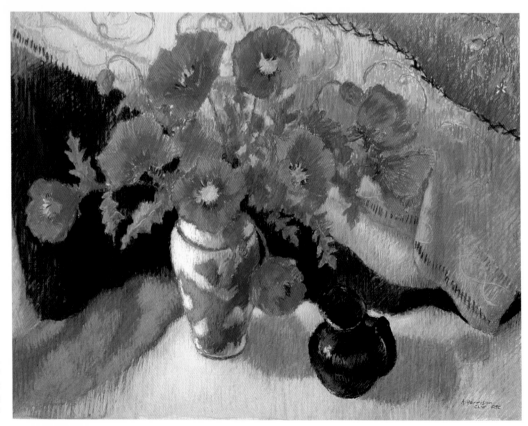

Agnes Harrison
Poppies
20" x 26" (50.8 cm x 66 cm)
Pastel with oil and turpentine
Ersta Starcke 7/0 sanded pastel paper

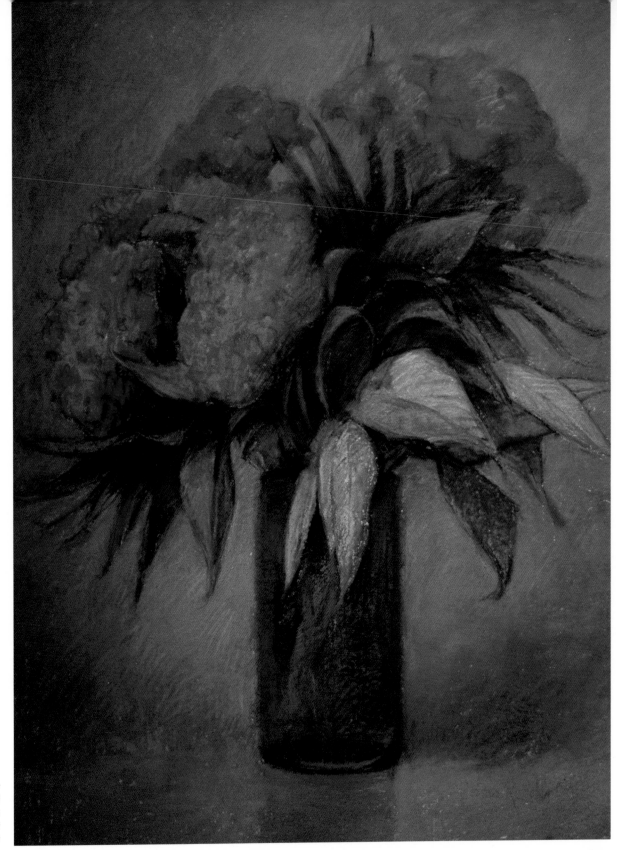

Mitsuno Ishii Reedy
Cocks Comb
29" x 22" (73.7 cm x 55.9 cm)
Pastel with watercolor
400 lb. Watercolor paper

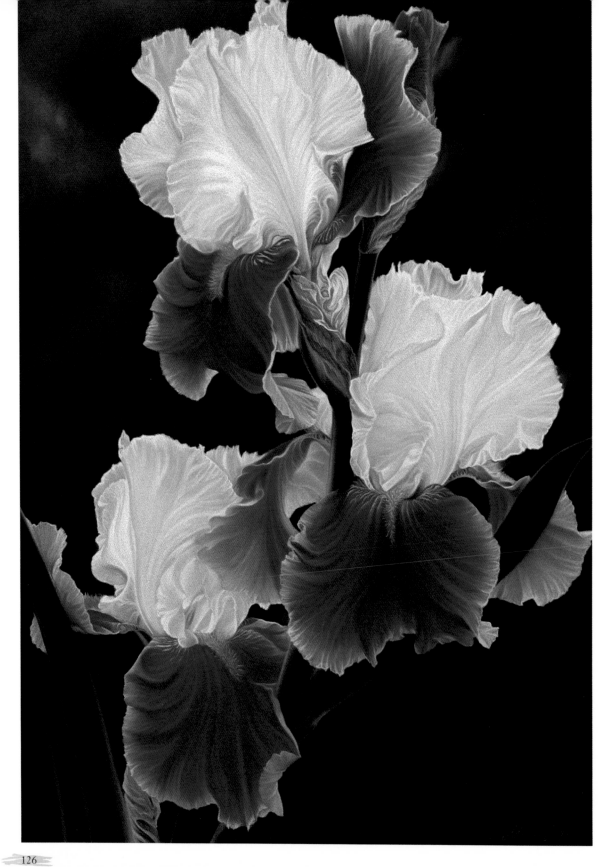

Miciol Black
Flirtation
28" x 20" (71.1 cm x 50.8 cm)
Canson Mi-Teintes 108 lb. paper

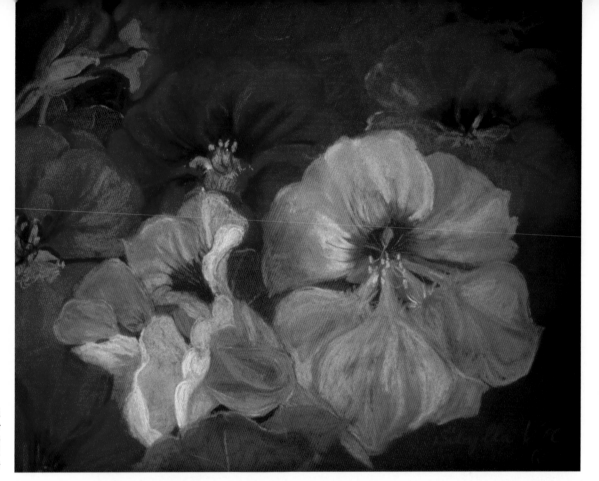

Sibylla Voll
Capucchins
15.5" x 18.5" (39.4 cm x 47 cm)
Pastel with vine charcoal
Ersta pastel sandpaper

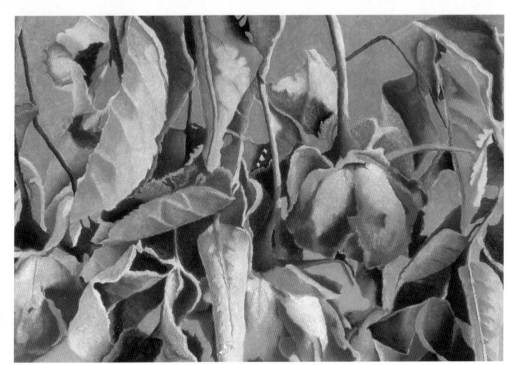

Donna Stallard
What Used to Be
30" x 44" (76.2 cm x 111.8 cm)
Rives BFK heavyweight gray paper

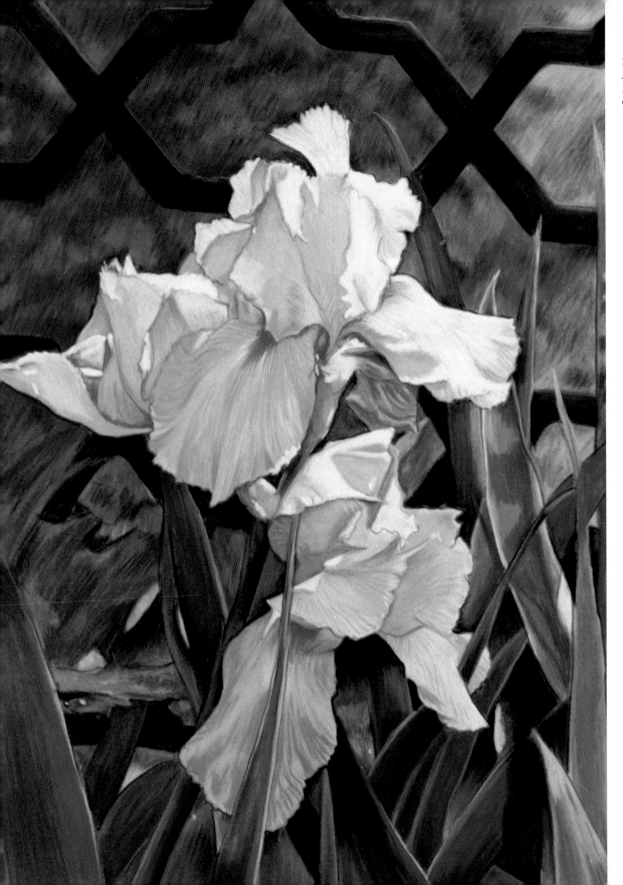

Kathy Shumway-Tunney
Along Prince Street © 1995
24" x 18" (61 cm x 45.7 cm)
65 lb. Velour pastel paper

Connie Kuhnle
Conversations
15" x 22" (38.1 cm x 61 cm)
Canson Mi-Teintes paper

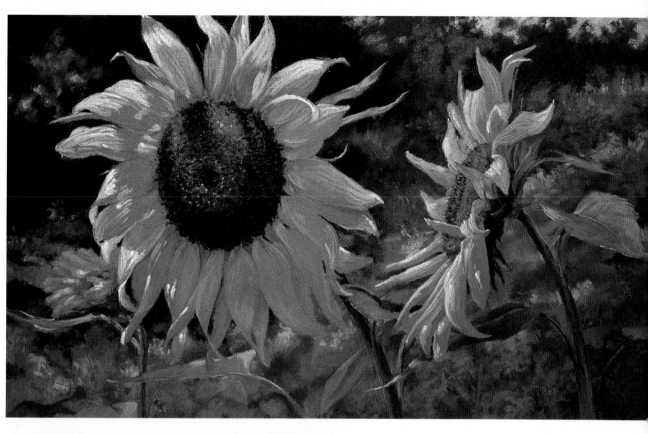

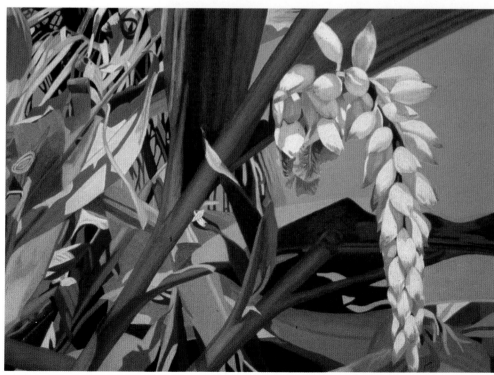

Toni Lindahl
Bahama Floral
23" x 32" (58.4 cm x 81.3 cm)
Arches 140 lb. watercolor paper

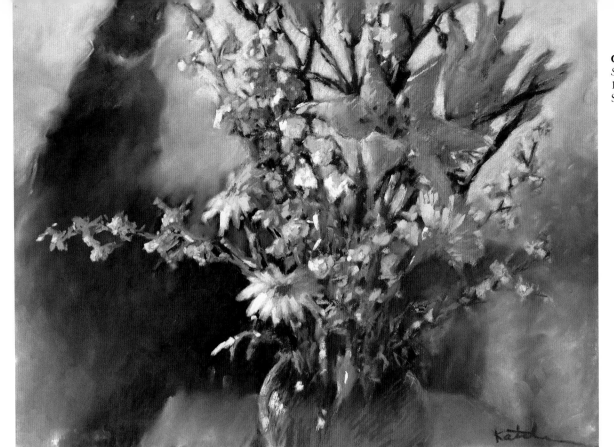

Carole Katchen
Silent Witness
19" x 25" (48.3 cm x 63.5 cm)
Sennelier La Carte pastel paper

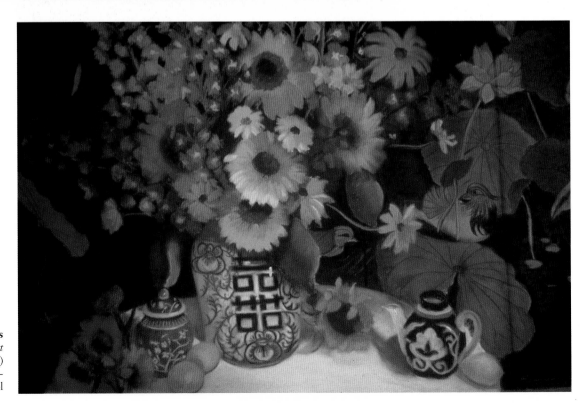

Patricia Suggs
Oriental Arrangement
24" x 36" (61 cm x 91.4 cm)
Canadian Sabretooth hand-
made acid-free bristol

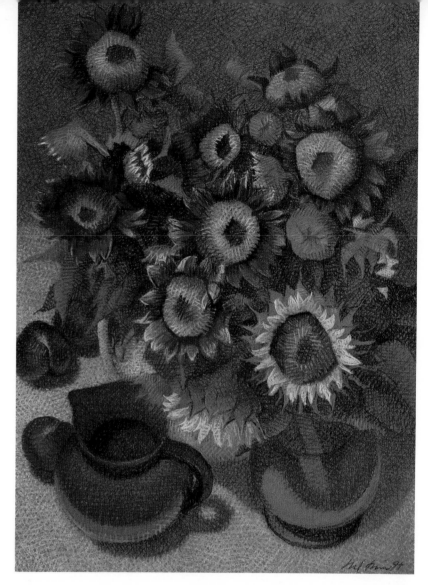

Makie Hino
Red Sunflowers
24.5" x 18" (61.9 cm x 44.9 cm)
Canson pastel paper

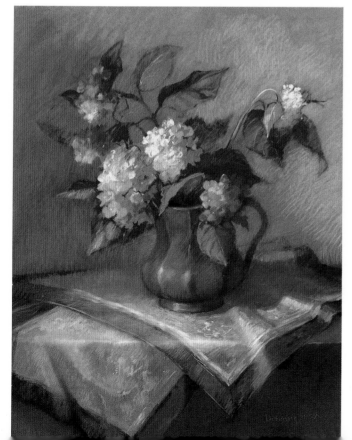

Christina Debarry
Hydrangea with Silk Scarf
24" x 18" (61 cm x 45.7 cm)
Sennelier La Carte sienna pastel paper

131

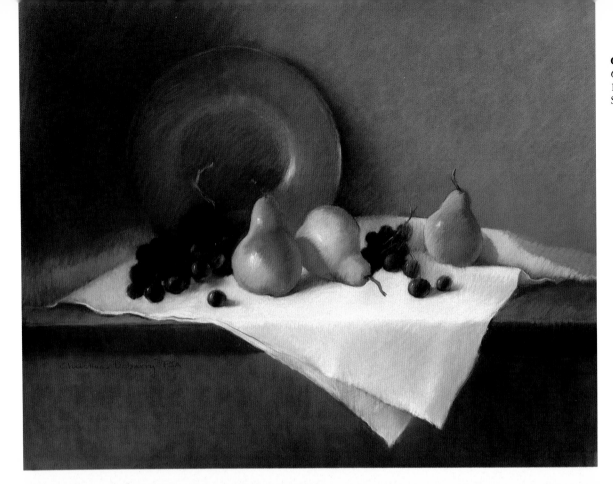

Christina Debarry
Golden Pears
18" x 24" (45.7 cm x 61 cm)
Sennelier La Carte pastel paper

Janet N. Heaton
Toto Town
12" x 28" (30.5 cm x 71.1 cm)
Schoëllershammer rag board

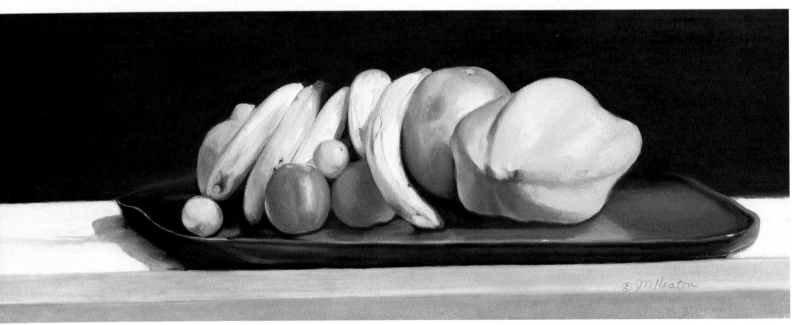

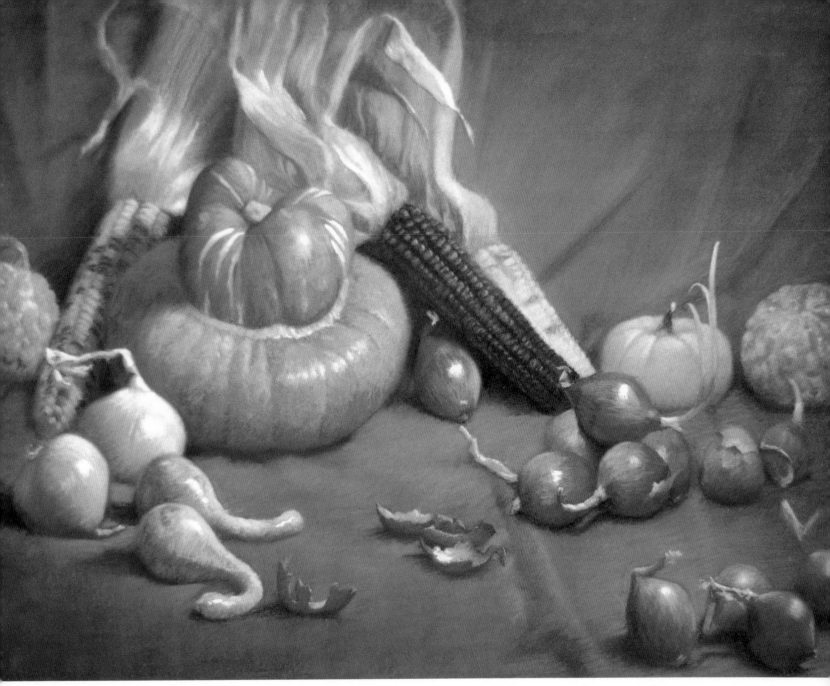

Salomon Kadoche
Fall Harvest
19" x 25" (48.3 cm x 63.5 cm)
Canson paper

133

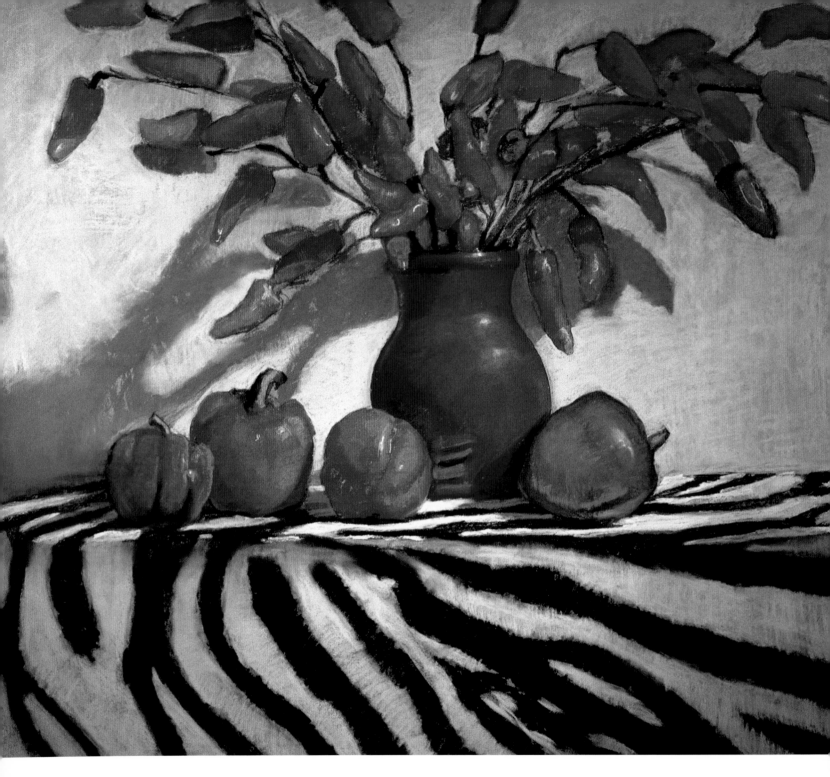

Deborah Nieto Leber
Dave's Peppers
29" x 30" (73.7 cm x 76.2 cm)
Pastel with turpentine
Canson paper

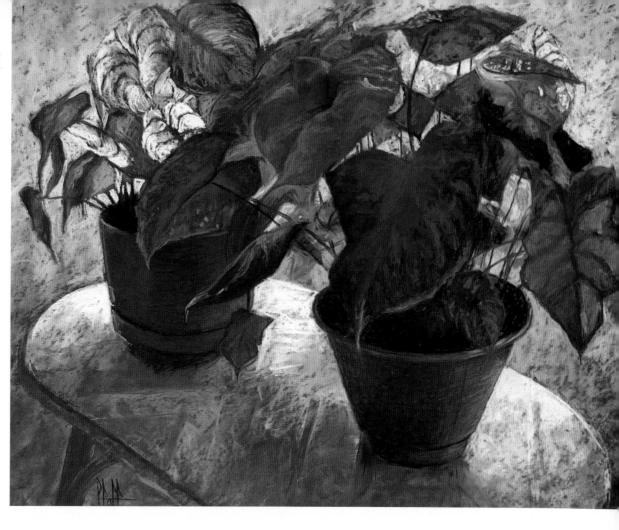

William Pfaff
Calladiums on a Pink Table
19" x 25" (48.3 cm x 63.5 cm)
Gesso- and pumice-treated foam core

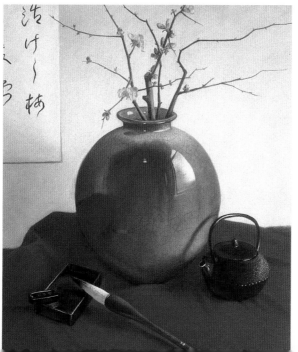

Marbo Barnard
Raku with Sumi Brush
23" x 18" (58.4 cm x 45.7 cm)
La Carte pastel card

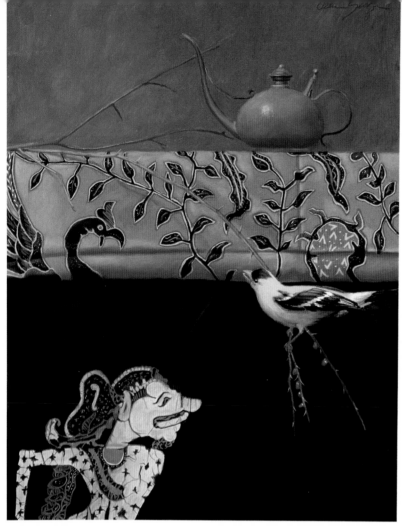

Peter Seltzer
East Meets West
25" x 19" (63.5 cm x 48.3 cm)
Sennelier La Carte pastel paper

Janice Ann Drevitson
Garden Festival
36" x 24" (91.4 cm x 61 cm)
Sanded panel

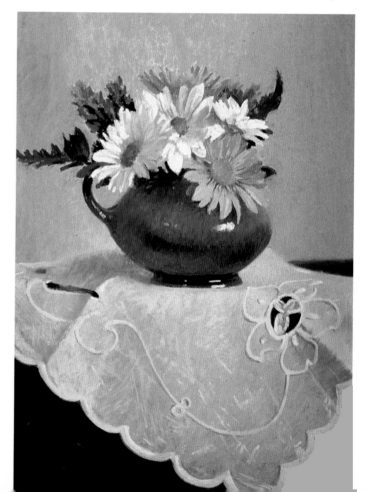

Thelma Davis
Silver Anniversary
20" x 16" (50.8 cm x 40.6 cm)
La Carte 200 lb. pastel card

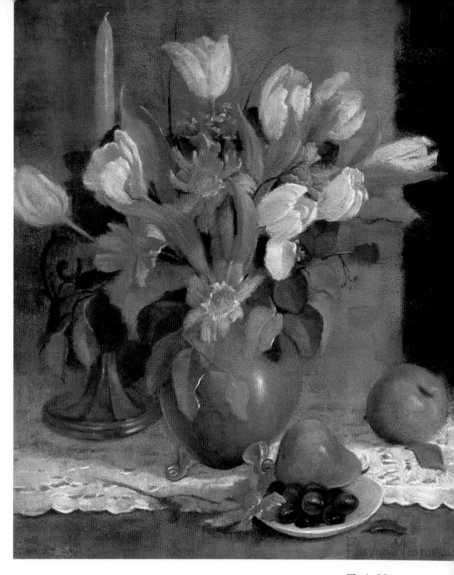

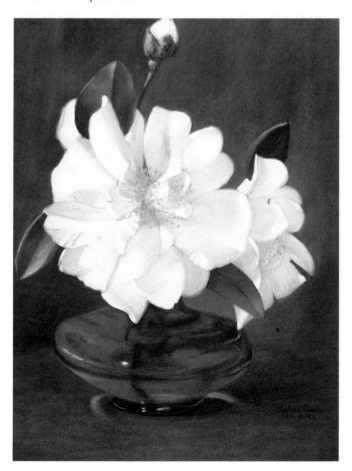

Flavia Monroe
White Tulips
24" x 20" (61 cm x 50.8 cm)
Pastel cloth

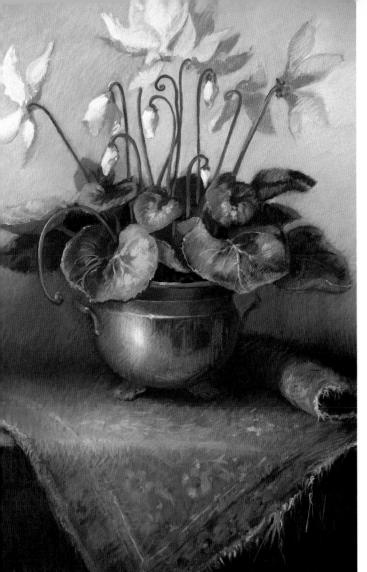

Christina Debarry
Cyclamen
24" x 18" (61 cm x 45.7 cm)
Sennelier La Carte sienna pastel paper

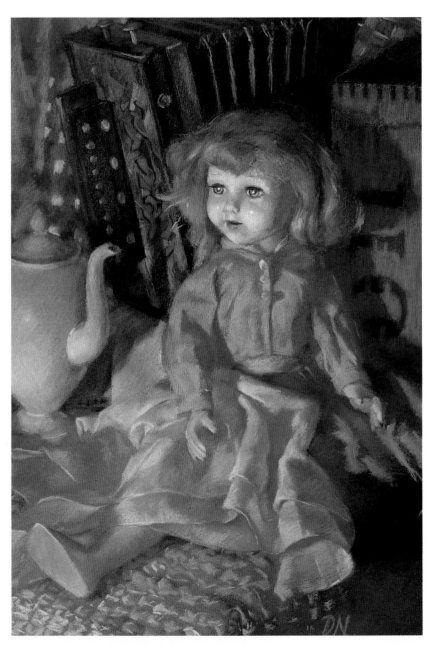

Donna Neithammer
Jess's Doll
19" x 14" (48.2 cm x 35.6 cm)
Canson Mi-Teintes paper

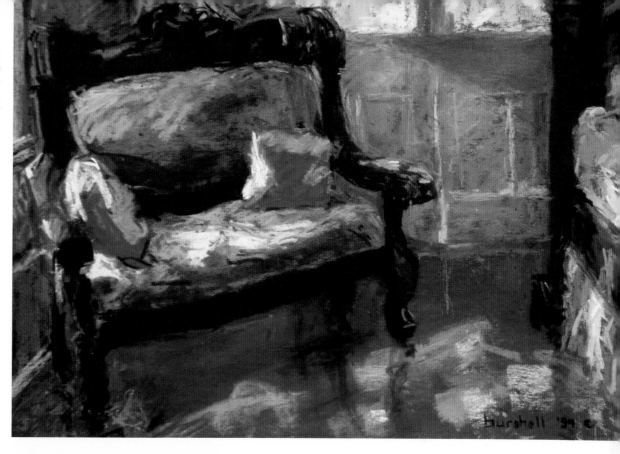

Sandra Burshell
Afternoon Comfort
7" x 10" (17.8 cm x 25.4 cm)
Ersta Starcke 7/0 grit sanded
pastel paper

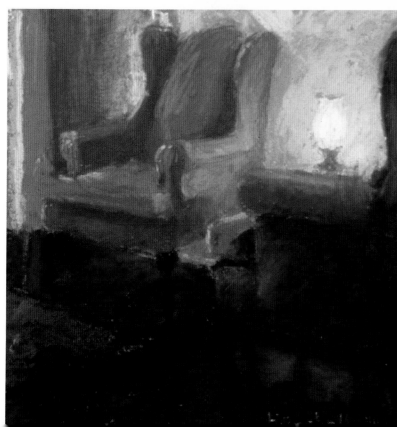

Sandra Burshell
Inviting
5" x 5" (13.3 cm x 13.3 cm)
Holbein Sabretooth paper

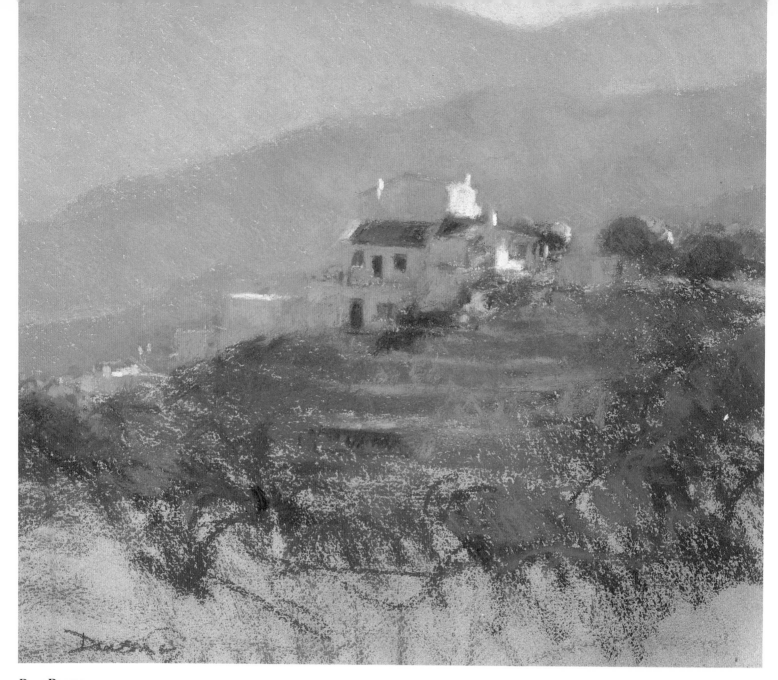

Doug Dawson
House in the Southern Mountains (Spain)
15" x 16" (38.1 cm x 40.7 cm)
German etching paper

About the Judges

Constance Flavell Pratt, born in Rockland, Massachusetts, graduated from the Massachusetts College of Art, and has studied with Rutledge Bate and Charles Mahoney. A brilliant portraitist, her work has been featured at the South Shore Art Center Gallery and The Copley Society of Boston. The winner of numerous awards, including Best Portrait from The Pastel Society of America in New York City, the Hudson Valley Art Association's Portrait Award, Pratt received the prize for Best Work on Paper from The Copley Society of Boston. A finalist at the first American Artists competition, Pratt has won prizes at the Springfield Art League Annual, the Academic Artists Association, Cape Cod Art Association, and at art shows throughout New England.

She has shown work at the Brockton Art Museum, Lion Gallery, Boston City Hall, Newport Art Association, Scarborough Art Gallery, and in New York City's Circle Gallery, Lever House and National Arts Club.

Janet Monafo was born in Boston, Massachusetts, in 1940. Since 1981 she has had a number of solo exhibitions at such galleries as the Allan Stone Gallery and the Sherry French Gallery in New York, and the Louis Newman Galleries in Beverly Hills. She has been featured in group exhibitions at the National Academy of Design and the America Academy of Arts and Letters in New York; the National Portrait Gallery in Washington D.C.; and the DeCordova Museum, the Fitchburg Museum, and the George Walter Vincent Smith Museum in Massachusetts. She has also exhibited at the Arkansas Art Center; the Weatherspoon Gallery, North Carolina; the Gerald Peters Gallery, Santa Fe; and Contemporary Realist Gallery, San Francisco. Monafo received a Fellowship from the National Endowment for the Arts in 1982, a New England Foundation for the Arts grant in 1994, and the Ralph Fabri Prize and a certificate in Merit from the National Academy of Design in 1988 and 1993. Her work is held in many public and private collections.

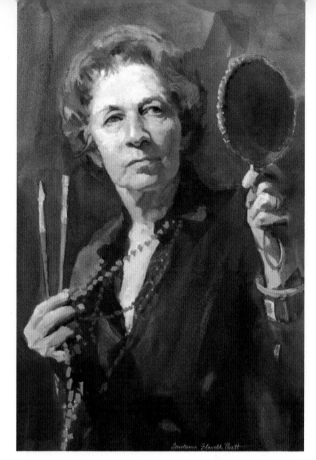

Constance Flavell Pratt
Self Portrait
22.5" x 16.5" (55.9 cm x 45.7 cm)
Pastel on watercolor

Index

Directory

Pamela G. Allnutt
1116 Wells Street
Iron Mountain, MI 49801

Donna L. Arntzen
421 Douglass Avenue
Richland, WA 99352-4314

Jill Atkin
2092 Musket
Eugene, OR 97408

Christine F. Atkins
154 Minimine Street
Stafford. Queensland. 4053
AUSTRALIA

Cathy Babcock
122 Rowayton Avenue
Rowayton, CT 06853

Alden Baker
22 Mountain Avenue
Summit, NJ 07901

Joann A. Ballinger
225 Lake Road
Bozran, CT 06334

Marbo Barnard
444 Q Street
Rio Linda, CA 95673

Georgiana Cray Bart
123 Brader Drive
Wilkes-Barre, PA 18705

Jann T. Bass
2700-B Walnut Street
Denver, CO 80205

Martha Bator
3432 Stratfield Drive NE
Atlanta, GA 30319

Violet Baxter
41 Union Street West, #402
New York, NY 10003-3208

Sue Bennett
1704 Northeast Cliff Drive
Bend, OR 97701

Miciol Black
4437 San Juan Drvie
Medford, OR 97504

Kay Bonanno
28 Oceanaire Drive
Rancho Palos Verdes, CA 90275

Andrea Burchette
11416 Meadowlark Drive
Ijamsville, MD 21754

Sandra Burshell
4812 Haring Court
Metairie, LA 70006

Marilee B. Campbell
316 East 2950 North
Provo, UT 84604

Vicky Clark
607 SW Avenue I
Seminole, TX 79360

Jack Coggins
P. O. Box 57
Boyertown, PA 19512

Jeanette V. Collett
8880 South Ocean Drive
Apartment 102
Jensen Beach, FL 34957

N. Marino D'Alessio
P. O. Box 225
Springfield, NJ 07081

Thelma Davis
6666 Acorn Hill
Placerville, CA 95667

Doug Dawson
8622 West 44th Place
Wheat Ridge, CO 80033

Christina Debarry
15 Ferncliff Terrace
Short Hills, NJ 07078

Christine Debrosky
141 Mount View Road
Tillson, NY 12486

Leslie B. De Mille
50 Cathedral Lane
Sedona, AZ 86336

Diana De Santis
34 School Street
East Williston, NY 11596

Mikki R. Dillon
662 Dorsey Circle
Lilburn, GA 30247

Harvey Dinnerstein
933 President Street
Brooklyn, NY 11215

Marnie Donaldson
1022 Bale Lane
Calistoga, CA 94515

Janice Ann Drevitson
Church Hill Road
P. O. Box 515
Woodstock, VT 05091

Neil Drevitson
Church Hill Road
P. O. Box 515
Woodstock, VT 05091

Anatoly Dverin
9 Oak Drive
Plainville, MA 02762

Elsie Eastman
345 6th Street
Brooklyn, NY 11215

Lilienne B. Emrich
3215 North Tacoma Street
Arlington, VA 22213

Loreta Kreeger Feeback
8519 Lee Boulevard
Leawood, KS 66206

Kaye Franklin
Route 1, Box 490A
Graham, TX 76450

Phyllis J. Friel
920 Tenth Street
Hermosa Beach, CA 90254

David Garrison
831 South Garfield
Burlington, IA 52601

Carole Chisholm Garvey
68 Chine Way
Osterville, MA 02655

Bob Gerbracht
1301 Blue Oak Court
Pinole, CA 94564

Susan Gerstein
1165 Park Avenue
New York, NY 10128

Flora Giffuni
180-16 Dalny Road
Jamaica Estates
New York, NY 11432

Wendy Goldberg
99B Wessen Lane
Fairfax, CA 94930

Beatrice Goldfine
1424 Melrose Avenue
Elkins Park, PA 19027

Maggie Goodwin
2981 North Lakeridge
Boulder, CO 80302

Albert Handell
P. O. Box 9070
Santa Fe, NM 87504-9070

Mary Hargrave
6 Colonial Avenue
Larchmont, NY 10538

Agnes Harrison
309 Shannon Circle
45th Street NW
Bradenton, FL 34209

Janet N. Heaton
1169 Old Dixie Highway
Lake Park, FL 33403

Sidney H. Hermel
41 Union Square West, R612
New York, NY 10003

Patty Herscher
4516 Longboat Lane
Fort Myers, FL 33919

Anne Heywood
85 Ashley Drive
East Bridgewater, MA 02333

Makie Hino
175 West 76th Street, #3G
New York, NY 10023

Roslyn Hollander
5 Dogwood Drive
Newton, NJ 07860

B. E. Hopkins
121 Rose Coral Drive
Panama City, FL 32408

Muriel Hughes
8840 Villa La Jolla Drive, #214
La Jolla, CA 92037

Alice Bach Hyde
110 Ichabod Trail
Longwood, FL 32750

Evelyn Inman
7001 West Vogel Avenue
Greenfield, WI 53220

Bill James
15840 SW 79th Court
Miami, FL 33157

Sandra A. Johnson
3550 Hawk Drive
Melbourne, FL 32935

Salomon Kadoche
1454 Orchard Road
Mountainside, NJ 07092

Carol Kardon
248 Beech Road
Wynnewood, PA 19096

Carole Katchen
624 Prospect Avenue
Hot Springs, AR 71901

Faye Kazdal
10105 231 Place SE
Woodinville, WA 98072

Susan H. Ketcham
6616 Blueberry Lane
Pipersville, PA 18947

Connie Kuhnle
10215 Young Avenue
Rockford, MI 49341

Al Lachman
4718 Snow Hill Road
Cresco, PA 18326

Mary Anne Lard
24 Sinclair Road
Mechanicsburg, PA 17055

Deborah Nieto Leber
221 Orchard Street
Cranford, NJ 07016

Kathy A. Legere
633 Ogden Road
New Lenox, IL 60451

Ann Boyer Lepere
6408 Gainsborough Drive
Raleigh, NC 27612

Donna Levinstone
1601 3rd Avenue, 17F
New York, NY 10028

Toni Lindahl
2120 New Garden Road
Greensboro, NC 27410

Anne M. McClure
P. O. Box 413
Ahwahnee, CA 93601

Gregory Stephen McIntosh
P. O. Box 961
Ojai, CA 93024

Joan D. Macnaught
9 Cranfield Street
Sunnybank Hills. 4109
AUSTRALIA

Mary Jane Manford
1602 Pease Raod
Austin, TX 78703

Herman Margulies
32 Revere Road
Washington, CT 06793

Denise E. Matuk-Kroupa
10 Elmont Avenue
Baltimore, MD 21206

J. T. Maxwell
1450 Stocton Road
Meadowbrook, PA 19046

Linda Meiegs
5215 Jackson
Omaha, NE 68106

Milton Meyer
5784 East Oxford Avenue
Englewood, CO 80111

Clark G. Mitchell
100 Firethorn Drive
Rohnert Park, CA 94928-1332

Janet Monafo
25 Theresa Avenue
Lexington, MA 02173

Flavia Monroe
2605 Rollingwood
Austin, TX 78746

Fay Moore
15 Gramercy Park South
New York, NY 10003

Elizabeth M. Mowry
287 Marcott Road
Kingston, NY 12401

Ned Mueller
13621 182nd Avenue SE
Renton, WA 98059

Jan Myers
8309 Benton Way
Arvada, CO 80003

Joyce Nagel
6 Honey Locust Circle
Hilton Head Island, SC 29926

Bettey Naymark
218 Forrester Road
Los Gatos, CA 95032

Donna Neithammer
23 Arrowhead Trail
Media, PA 19063

Marsh Nelson
185 Edgemont Avenue
Vallejo, CA 94590

Susan Ogilvie
P. O. Box 59
Port Hadlock, WA 98339

Desmond O'Hagan
2882 South Adams Street
Denver, CO 80210

Cheryl O'Halloran-McLeod
1318 Belleview Avenue
Plainfield, NJ 07060

Parima Parineh
20978 Sara View Court
Saratoga, CA 95070

Judy Pelt
2204 Ridgmar Plaza, #2
Fort Worth, TX 76116

S. S. Pennell
6 Upland Road
Lexington, MA 02173

William Pfaff
5417 Courtland Road
Springfield, TN 37172

Alexander C. Piccirillo
26 Vine Street
Nutley, NJ 07110-2636

Barry G. Pitts
P. O. Box 14526
Long Beach, CA 90803

J. Alex Potter
P. O. Box 1172
Hutchinson, KS 67504-1172

Mary Poulos
16 Winona Trail
Lake Hopatcong, NJ 07849

Constance Flavell Pratt
23 Tiffany Road
Norwell, MA 02061

Diana Randolph
Rural Route 1, Box 66-C
Drummond, WI 54832

Mitsuno Ishii Reedy
1701 Denison Drive
Norman, OK 73069

Junko Ono Rothwell
3625 Woodstream Circle
Atlanta, GA 30319

Nicholas Sacripante
9411 Moorehead Lane
Port Richey, FL 34668

Dorothy Sandlin
3239 West 205th Street
Olympia Fields, IL 60461

Margot S. Schulzke
1840 Little Creek Road
Auburn, CA 95602

Judith Scott
6658 South Gallup
Littleton, CO 80120

Susan E. Selig
28346 Briggs Hill Road
Eugene, OR 97405

Peter Seltzer
29 Paddy Hollow Road
Bethlehem, CT 06751

Mary Gayle Shanahan
917 Gilbert Street
Helena, MT 59601

Kathy Shumway-Tunney
105 Walnut Street
Bordentown, NJ 08505

Dan Slapo
155-15 Jewel Avenue
Flushing, NY 11367

Katherine Smit
Box 2021
Duxbury, MA 02331

Peggy Ann Solinsky
541 Monroe Units
Denver, CO 80206

Donna Stallard
413 South O'Connor
Irving, TX 75060

Lucille T. Stillman
8 Drum Hill Lane
Stamford, CT 06902

Sally Strand
33402 Dosinia Drvie
Dana Point, CA 92629

Thomas J. Strickland
2595 Taluga Drive
Miami, FL 33133

Patricia Suggs
4127 Beebe Circle
San Jose, CA 95135-1010

Urania Christy Tarbet
P. O. Box 1032
Diamond Spring, CA 95619

Merriel Taylor
22800 Latrake Raod
Plymouth, CA 95669

Janis Theodore
274 Beacon Street
Boston, MA 02116

Dorothy Davis Thompson
1612 Bear Creek Road
Kerrville, TX 78028

Eugenie Torgerson
P. O. Box 176
Lakeside, MI 49116

Valerie Trozelle
40-601 Starlight Lane
Bermuda Dunes, CA 92201

Lorrie B. Turner
14 Village Drive
Huntington, NY 11743

Coralie Alan Tweed
915 East 8th Avenue
Johnson City, TN 37601

Claire Schroeven Verbiest
3126 Brightwood Court
San Jose, CA 95148

Sibylla Voll
2938 Avenida Theresa
Carlsbad, CA 92009

Kitty Wallis
729 Bay Street
Santa Cruz, CA 95060

James E. Welch
585 South Huron Road
Harrisville, MI 48740

Marie Kash Weltzheimer
2724 NW 45th
Oklahoma City, OK 73112

Charlotte Wharton
594 Chandler Street
Worcester, MA 01602-1231

Madlyn-Ann C. Woolwich
473 Marvin Drive
Long Branch, NJ 07740

Rhoda Yanow
12 Korwell Circle
West Orange, NJ 07052

Frank E. Zuccarelli
61 Appleman Road
Somerset, NJ 08873